自序 Preface

4

人生是一場踏上未知的魔幻旅程。

出繪本好像是每個插畫家的人生目標清單之上必有的一項,但它又好像聖杯一樣只能遙遠地觀望著它發光,是觸不到的目標,要得到出版社賞識幫你出書根本是傳說般的存在。

我很慶幸畢業後三年就得到這個機會,說實在是一個挺完美的時間點,碰巧手頭上沒有太多會霸佔大量時間的工作,讓我能夠在輕鬆、沒有壓力的環境之下慢慢雕琢出這本書。除了新的畫作,過往幾年畫下的作品亦足夠豐富,作為繪本連精選集去回顧我過往的點點滴滴再適合不過了。

當初白卷出版社希望和我合作出一本關於香港的繪本時,我首先是探究自己與香港的關係,1995 出生的我可以說是對英國殖民統治下的香港沒有印象,但總會在長大後從父母口中慢慢聽到當年的生活片段、他們聽的歌、追逐過的名牌與明星,在街道上又會看到當年遺留下的英式建築物,我只能零碎地拼湊出對那個黃金時代香港的印象。

《巫人之境 Spellman's Land》便是建基於這個想法上而創作,它不是完整地還原舊時代的香港,反而更像是從不同年代拼貼出的香港。當然再加上我對魔法世界的鍾愛,你們便看到這樣色彩斑斕,猶如使人跌入魔幻漩渦的香港。為了新書,我畫了 30 幅全新的插畫,大概花了半年的時間,差不多是我的極限了。在《巫人之境》當中,你們能看到不同性向的

人、各種神話動物、自帶靈氣的貓、給我重新想像的建築物、童年回憶等等，希望你們能欣賞到，我眼中美麗而魔幻的香港。

除了插畫之外，我亦是首次發佈我寫的新詩，因為我覺得詩能好好表達畫中的情緒，但又保留一定的想像空間，而不是一段解釋性質的文字。在寫作上我不是專家，我只是把我當刻的感受，及纏繞在腦海的回憶，毫無保留地寫下來。

最後我想多謝白卷出版社所有幫過我的編輯，他們是真心喜歡我的畫作，很體貼地幫助我這位出書新手。我還要多謝我的家人，他們從我執起那枝改變我人生道向的筆開始，無條件地支持我，成為我背後強大的盾牌。我亦想對那些我愛過的男人說聲謝謝，縱使他們現在都不在我身邊，但他們曾經的愛會長存在我心中，為我的作品注入靈魂。最最最後要感謝的當然是此刻在讀著這本書的你們，無論你是我的巫範生粉絲，還是第一次認識我的讀者，感謝你們買下我這本處男作，沒有你們的支持，便不會有我 Isaac Spellman 巫男的今日。

推薦序 Foreword

謝安琪 Kay Tse
歌手 Singer

Spellman's Land is a collection of works that beholds a place which is deeply loved and a space that is wildly imagined.

The style of Isaac's works stands out and makes bold impressions even in just a glance.

楊文蔚 Cecilia Yeung
跳高運動員 High Jump Athlete

週末，我愛開著自己的古董車，車上播著披頭四歌曲，歡快俏皮的旋律化成音符的波浪，我如坐在時光機回到過去。這個感覺和我首次踏進 Isaac Spellman 巫男的插畫展覽《Lust for Life》一樣，整個畫面都蒙上舊時光的韻調。

跟不少人一樣，我嚮往以前的世界，步伐慢一點，多點人情味，沒有網絡世界，沒有 Like 數，管不著遠在天邊的事，在乎的只有身邊的人。可惜，我沒有逆轉的超能力，不可將時間撥到早一百年的春天，而過去跟未來一樣都是我們不能控制的領域。但若然你看過巫男的畫作，就會理解何謂置身於魔幻國度內，因過去與未來皆弄於他畫筆上。

《巫人之境》，畫册之名改得太好，Isaac 説過畫中的一切都是建設他心目中的烏托邦，是藝術家創造的美好世界。在巫男的無人之境，他一筆一畫地把嚮往的六、七十年代的舊香港呈現出來。（六、七十年代的舊香港啊！是我魂牽夢縈的時代，是有披頭四的美好十年）但此舊香港不同彼舊香港，畫中的主人翁不只身穿長衫、頭梳堆雲裝，而且他們還會腳踏滾軸溜冰鞋和背著 Jacquemus 小廢包；在茶餐廳喝著香港聞名黑白淡奶沖的奶茶，奶茶卻成了小精靈的泡泡浴；小孩在屋邨公園遊樂場的攀爬架上遊玩，金魚竟在天空中游動！一幅幅烏托邦結合過去、現在、未來，時間的界限早已拋開，卻充滿歡樂氣息，在城市一隅繪出超現實的平行時空。

人愈長大，愈驚覺許多事控制不了。經過這幾年的日子後，我們發覺只可把心中的聯想都放在畫中的魔法世界，任由夢想的寄託在潛意識中一直蔓延。

何純穎 Katherine Ho
香港 VOGUE 資深時裝編輯
Senior Fashion Editor of VOGUE Hong Kong

如果回到香港的黃金時代，會是什麼樣子呢？

作為 90 後，總是對王家衛電影美學一往情深，對於王菲的音樂更是如癡如醉，這就是自己眼中的黃金時代。而曾經是所有 90 後童年回憶的廣東歌《黃金時代》，當中林夕說的並非是當下最繁華昌盛的香港，也不是形容陳奕迅的生涯巔峰，反而以黃金廣場和時代廣場的鬥比喻新舊時代之分。同時林夕歌詞間被認為流露出與王小波《黃金時代》一書同出一轍的味道，前者努力愛過、享受過的純粹之愛，後者透過恣意大膽的性愛彰顯出社會荒誕不經真相的嘲諷，對人性、生命和自由的愛。

Isaac Spellman 的《巫人之境》則開創了屬於自己的黃金時代，乾淨俐落的筆觸描繪出復古輪廓，搭配上極為豐富的獨特色彩，造就出充滿未來主義和超現實主義的插畫風格。「我一直在想，生活在過去香港的黃金時代是什麼感覺？」被問到創作《巫人之境》的概念，Isaac 把自己幻想世界視覺化：《Back to the Future》經典的時光機 DeLorean 在傳統屋邨前奔馳，小露寶、美人魚、獨角獸等大量童年玩具，與現實流行文化元素交織，總是讓人出乎意料。

如果你仔細看精美絕倫的插畫構圖，會發現 Isaac 是個時裝愛好者，此話怎講？Jacquemus 迷你手袋、Gucci Monogram 圖騰、經典服裝線條等等，不乏流露出自己對時裝的熱愛，甚至首次收到《VOGUE》香港版合作邀請的時候，主動建議為每個角色賦予不同的時尚風格，完美融合 Future Nostalgia 的美學。

其實香港這個城市談創作是件不容易的事，但卻是臥虎藏龍之地，論入圍及獲獎的國際獎項從 3X3 國際插畫比賽優選獎、CA 美國傳達藝術獎、D&AD 設計與藝術指導全球創意獎到 WIA 世界插畫獎都有，論時尚品牌有 Vivienne Westwood，藝人合作有 Lady Gaga，比比皆是。僅 26 歲的 Isaac 就憑著獨特畫風闖出國際。黃金時代在這裡不是歷史概念，畢竟歷史本就是動盪不安，但無論是生於哪個時代，只要盡情地愛、盡情地追夢，你我都是活在黃金時代。

陳菁 Chan Ching
文字工作者 Writer

黃金的魔幻詮釋

要說黃金時代，可真是略感尷尬。這個詞彙，就算不和白紙黑字上的銀碼連上關係，也總關乎自身利益。假如要上一代勾勒他們的黃金時代，大多和名利有關，故事類似是很努力於是上了行業神枱，或是在太古城買了單位數個，大同小異。故此，在 Isaac Spellman 預告其著作會圍繞城市的黃金時代時，我沿著尾龍骨一帶都冒起冷汗。

直至看過《巫人之境》收錄的幾幅作品，才理解到他眼中的黃金是一種魔幻的色彩、一種海納百川的美學。城內，凌晨的便利店裡會遇上在唶海鮮杯麵的獨角獸；男爵無懼香港濕熱，四季都穿得官仔骨骨，隨時營救下一位月島雫；是人或獸或未知物種，大家都好奇而相敬地共存著，偶然相約看黃昏。Isaac 的黃金時代可以倒數至五十年前，但他筆下的魔幻，想必是任何年代皆宜。只要日子有苦澀感，魔幻之境就是必須傍身的休憩工具。

和 Isaac 多次合作，由心覺得新一代插畫家不易當。他說自己沒有公眾假期的概念，在眾多合作過的藝術家中，若計作畫和回覆訊息的速度而言，他想必會包辦雙料冠軍。一次請他畫許鞍華《第一爐香》圖，要以原作者張愛玲為主軸，他把爐轉化為張愛玲的旗袍圖案，幾縷輕煙和背後的藤蔓紋理融和，見微知著，他總是把畫和思想混合得和諧。畫中兩個張愛玲裡，側著臉的一位竟有幾分像《傾城之戀》的繆騫人，於畫中尋寶，不難找到散落的彩蛋。品嚐他作品中的選色，固然是一場視覺饗宴，但心思才是回家路上久久未散的餘韻。

李凱儀 Alice Lee
「說故事」創辦人 Founder of Ztoryteller

屬於你的黃金時代

出生於 80 年代,那個黃金時代繁華美麗的回憶碎片組成了我的快樂童年。

還記得 90 年代香港電影業盛行,每個週末我們定必一家人到灣仔道一間大戲院看電影。戲院門外是一個個賣美食的小販檔,令我印象最深刻的是焞魷魚,那炭香味總是飄散到整條街不同角落。穿著白色背心的大叔在燒得香噴噴的魷魚塗上自製的燒烤汁,再剪成小長條,放進紙袋裡,遞到我的小手裡。印象中每一個電影夜都是人山人海,要排隊進入戲院。等待期間,有時候我會問媽媽拿一個硬幣玩磅重機,投入硬幣後,機器內的燈泡就會一閃一閃的,接著彈出標示著體重的小卡片。然後,小小的我快樂地把卡片放到小袋子裡。回想起來,一張標示著體重的卡片有什麼值得收集的?那時候的我大概覺得那橙色的機器似是有魔法般神奇。迷人的燈光、熱鬧的人聲、撲鼻的香氣……所有煩惱在那一刻似是離我們很遠很遠。那一切回想起來的確都籠罩著魔幻的淡黃色彩。

來到這個新時代,環境已截然不同,即使一切面目全非,但我依然看到這個城市獨有的魔幻色彩。在年輕的新世代中,我看到無限的創造力。我們不再活在紙醉金迷的黃金時代,在享受美酒佳餚前,我們懂得先餵飽靈魂。在這裡,特別創業的這幾年間,我遇過很多非常有才華的年輕創作人透過藝術帶給我們很多美好的想像和力量,滋養我們的靈魂。其中一位是此書《巫人之境》的作家 Isaac。從他大學畢業時就相識,看著他不斷進化成長,一直很欣賞他的自信和對插畫藝術獨有的觸覺,很早就建立起鮮明的個人風格,這是非常難得的。所以,非常高興他邀請我為此書寫序,讓我有機會慢下來在腦海仔細回想那夢幻的時光,

也讓我有機會見證這年輕人再次用他那如魔法般的畫技帶讀者走進屬於他的黃金時代。

每一個年代都有著美好的一面，同樣都有它的苦和脆弱。希望大家從此書中一幅幅魔幻的畫作裡獲得一些力量，啟發你的想像，創造屬於你的黃金時代。

翻譯（中文文稿）
Translator (Chin. text)

｜ Ken Wong

10:10 am

Sometimes I wake up in the morning,
To red, blue, and yellow lights,
And you...
By my side.

有時早上
在紅藍黃的光暈下醒來
而你
就在我身旁

White Mustang

Driving alone in my white mustang,
Goin' 60 cause I don't like speed,
Fearing I might crash,
Crashed into a thousand pieces of debris.
You said don't rush things cause you'll panic,
So I gave you space but what did you give me?
Empty seats and empty promises.

I drive myself insane,
Asking why,
What did I do wrong?
I just want you,
Want you to be happy,
But you wouldn't let me in so I distanced myself,
A safe distance so I wouldn't crash,
And you thought I'm cold like ice,
Just trying to be nice.
By the moment I knew,
You already left,
A thousand cuts to death.

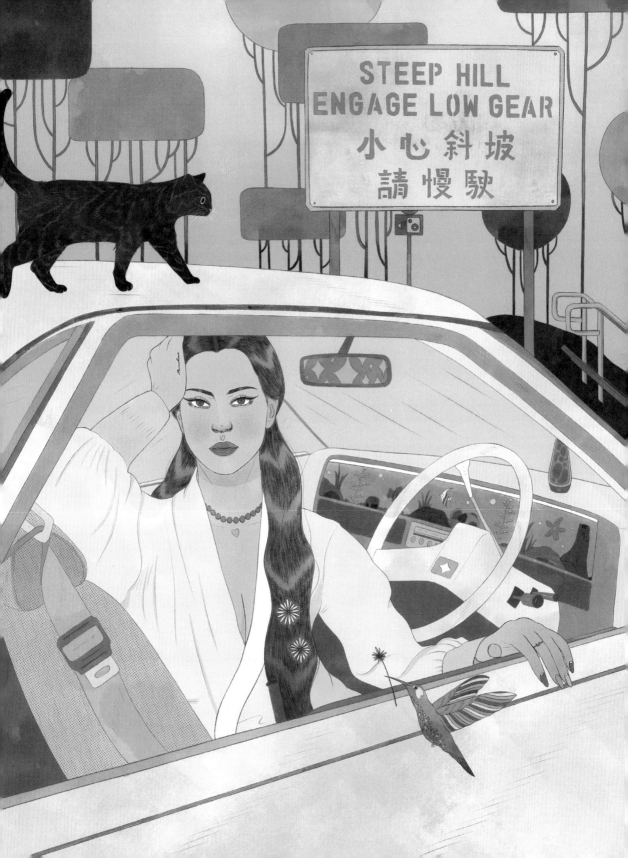

／白色的野馬

獨自駕著白色的野馬
時速六十，我從不愛速度
深怕會車毀人亡
四分五裂

你說：慢慢來，因我會怕
我給你空間，只換來
無人座椅與空洞承諾

帶著疑問
我駛向瘋狂
我的罪名是什麼？
「只想你快樂」
你不讓我靠近，我便退開
至一個安全的距離

你看見的冷酷
只是我的溫柔
我明白那時，你早已遠去
留下千萬道疤痕

Black Coffee

Black coffee, no sugar, and no milk,
That's how you make it for me,
Morning kisses, overload sweetness,
Cooked me dinner,
Sooner or later,
names signed on papers.

Picture in my head,
Blooming roses painted in red,
Covering the fact,
No one wants me, lonely and sad.

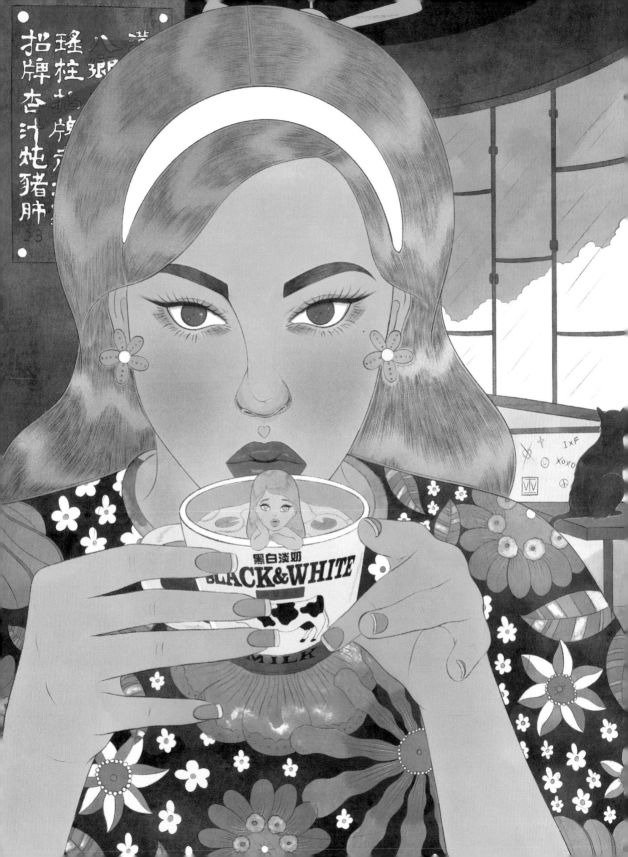

／齋啡

走糖走奶
齋啡你為我準備
早上的吻，滿溢的甜
晚餐你為我呈上
遲或早
在盟約簽上姓名

僅是腦內迴響
怒放玫瑰的火紅幻想
覆蓋了真相：
孤寂與哀愁，我一人獨享

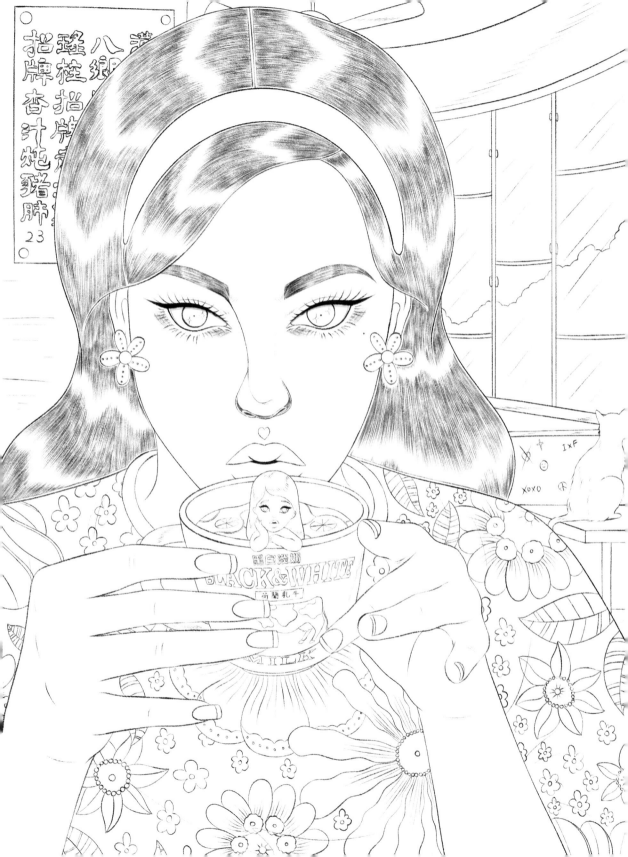

Getaway Car

I wanna take you for a ride,
On my newly bought Cadillac,
I will be driving the getaway car,
You will be gazing upon the star.
Getting away from cities,
Into the wild.

You said I'm wild at heart,
I said it's the engine that you start.
You make me soar and roar,
Like a tiger full of life.

But one day you stopped adding fuel,
Dazzled and confused,
I thought that's what you want,
No signals and confront,
No chances to fix and run,
Just left me there,
Wondering could it be undone?

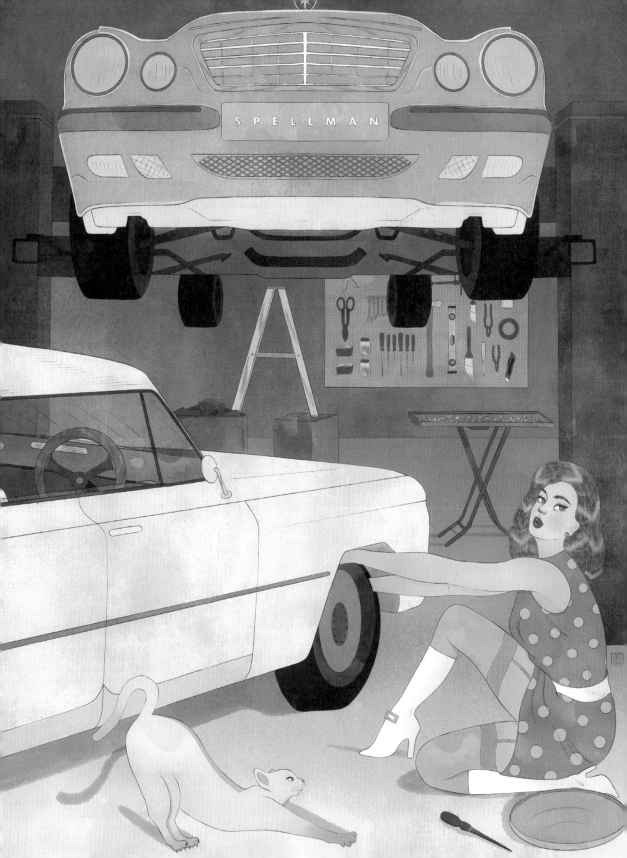

／高走高飛

我願帶你上車
坐上全新的卡迪拉克
我帶你高走高飛
你仰望繁星的美
遠離塵囂
浪蕩天涯

你說，我天性狂野
我說，這因你而起
像爆發生命的獸般
我學懂吼叫和飛翔

直至一天，你熱情不再
情迷意亂的我
以為這是你的願望
沒有回信或對峙
沒有逃避或救贖
只有你留下的孤獨
妄想
或可回到最初

Wild Horses

The old money,

How easy for them to call me honey.

I'm like a wild horse they want to tame,

A love game they want to play.

Taking me to Happy Valley,

I call him daddy,

He makes me happy,

But I'll always be the wild one,

Sleeping on my own bed instead of his,

No matter how many pretty flowers or gifts,

I'll never become his Mrs.

I belong to no one, to everyone,

I said come to me,

You said there can be no three,

I'm wandering free.

Who am I? Who am I to love?

I'm just like the wild horse,

Chasing no one,

Running on my own racecourse,

No more thoughts.

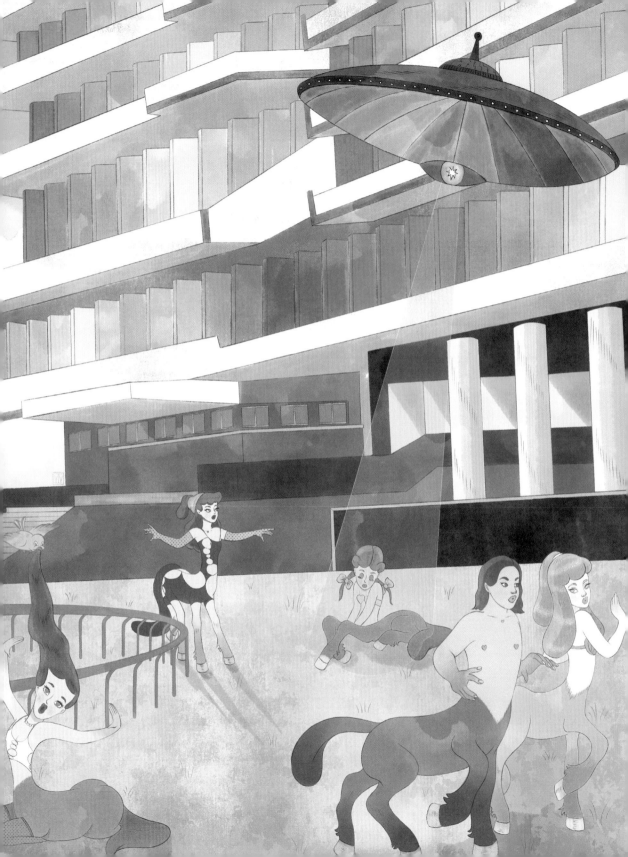

／野馬

有錢仔

說句「親愛的」多麼容易

我是一匹他們渴望馴服的野馬

一場愛情遊戲帶我到跑馬地

我叫他爹哋

他讓我欲仙欲死

但我永遠不羈

自己的牀自己睡

奉上多少鮮花與銀具

我也不屬他

不屬任何人

我喚你過來

你說，我會是唯一

我不怕迷失

我是誰？有何資格去愛？

我是一匹野馬

沒有主人沒有家

我有我跑道

不需要思路

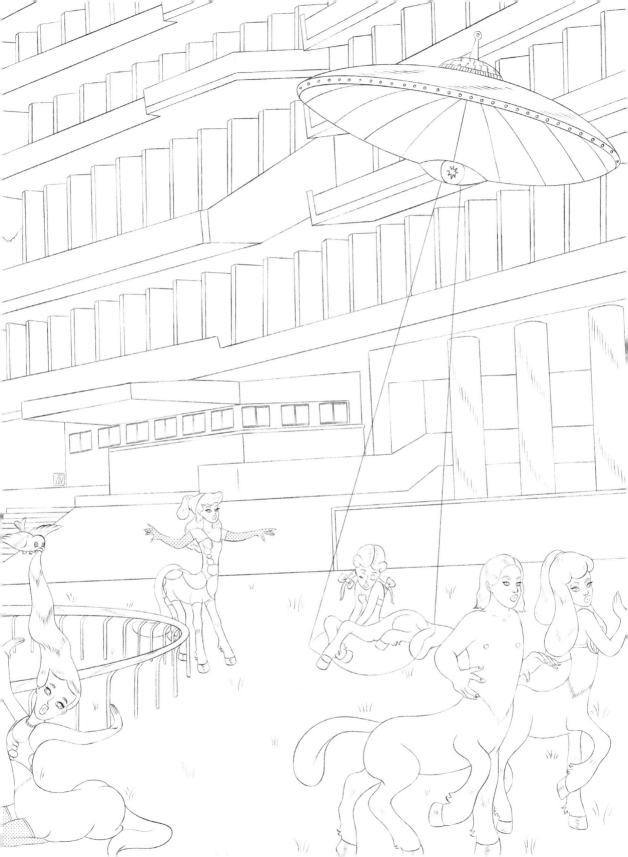

Mahjong

Four walls,

Always showed up when I called.

Touched the emerald green since I was thirteen,

East, South, West, and North,

Witches call upon the corners,

Sitting in circles.

Pung!

Kong!

Our wills are strong and we can do this all day long.

Mahjong bonds our sisterhood,

We understand and see the goods in each other,

Playing for 24 rounds,

Long hot summer,

Lost count of the numbers,

Turned into a slumber party,

Dancing to Cardi B,

Young, wild & free.

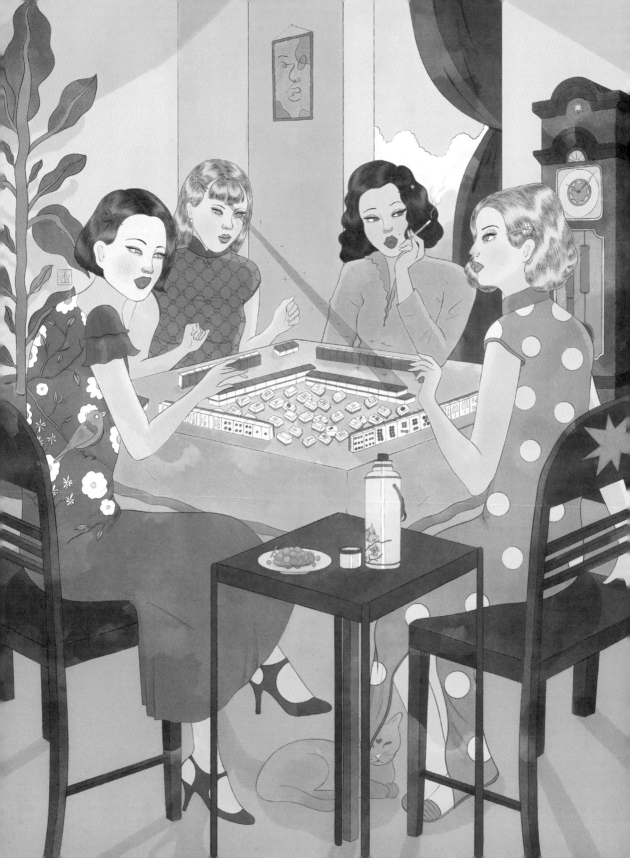

／麻雀

四方城，有求必應
十三歲，首次搭上翡翠綠
東，南，西，北
女巫圍圈而坐，呼召四角
碰！
槓！
憑鐵一般意志
奮戰至最後一刻

麻雀是姊妹情
了解每一面
發掘對方美善
打足廿四圈
悠長盛夏
忘了花落誰家

轉身睡衣派對
在 Cardi B 的歌裡起舞
年輕、狂野、自由

12:23 pm

Laying on my couch at noon,
Just chilling.
Bright white sunlights lighted up my living room,
Am I going to fall in love soon?

躺在沙發的中午
無所事事
白日照亮客廳
彷彿聽見愛情的腳踏聲

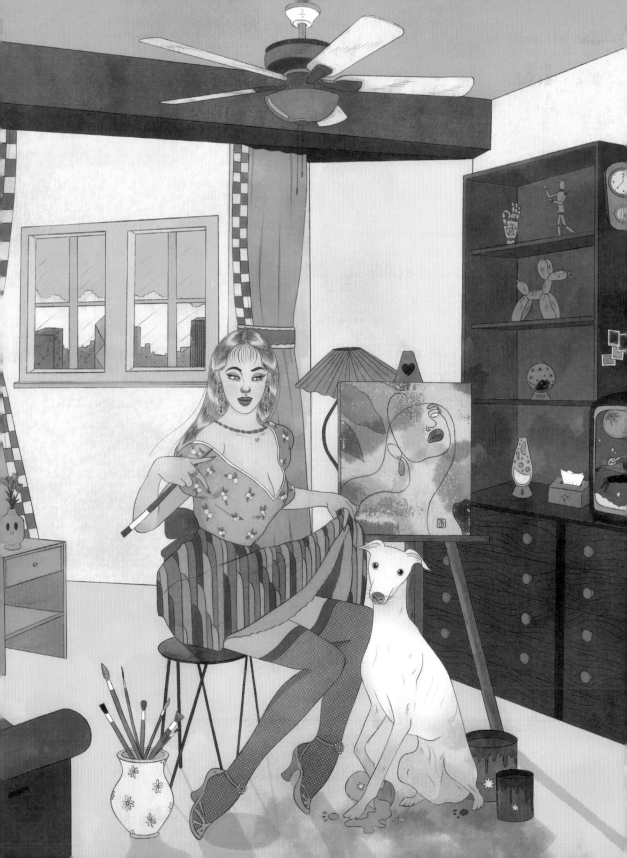

Artist

Artist is a fragile being,

And the work we make reflects our feeling,

The art of being fragile.

You said you like my art,

But what you don't see is the darkness behind the canvas.

One day I woke up at 6 in the morning,

Writing these exact lines,

I don't care what time it is.

Like a spider spitting web,

Can't stop until it finished weaving.

Like a fountain flushing out water,

Can't stop until it's over tourist hour.

God I'm sleepy,

Planting seeds in my head,

Can't stop until it grows into a tree.

I want you to understand me but even I don't,

Don't understand why I'm so cold.

I know my worth but not in the realm of love,

Making art is the only thing I trust.

So when you're making love with me,

I feel like I'm making art.

You trace your fingertips around my hips,

Like driving up the valley,

Like sculpting the statue of liberty,

Finally, I'm free.

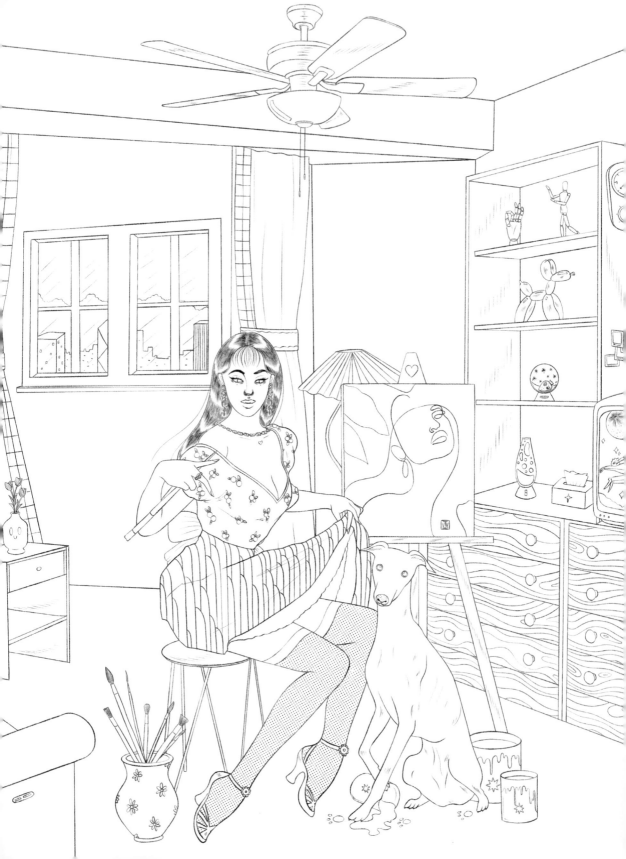

／藝術家

藝術家很脆弱
作品反映我們的心情
展露脆弱的藝術
你說你喜歡
但你看不見
畫布後是黑暗

一天我在清晨六點起牀
寫下這些詩句
時間與我無關
似蜘蛛吐絲
蛛網築起前，絕不歇息
像噴泉躍動
遊人離去前，永不停止
天啊，多麼疲倦
要在腦袋埋下種子
長出樹木前永不停止

我希望你諒解我
即使我也不懂我
不懂我為何總是冷酷
我的價值，不在情愛的世界
創作是我的唯一信仰
當我們在做愛
我感覺在做藝術
當你的指尖遊走至我的腰間
似駛入一座山谷
如雕刻一座神像
終於，我自由了

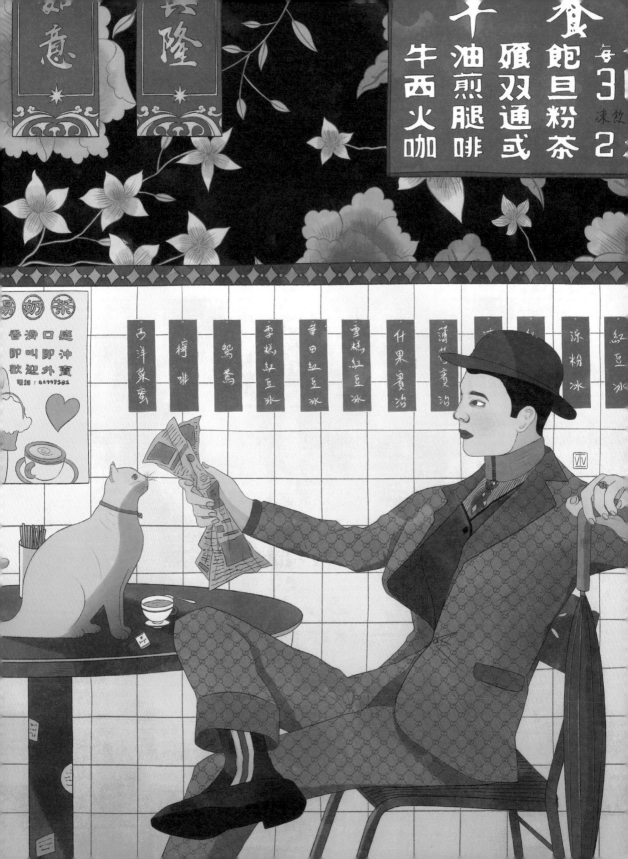

King's Man

Sitting across the table,
Face sculpted like pearl marble,
Eyes wrote trouble,
Body like Leyendecker,
Couldn't you be sexier?
Radiating a sense of fear,
Are you on a mission?
A secret rendezvous.
If only I knew,
You are just trying to be daddy cool.
Look at you look at me,
We could be the perfect match.
Invite me to a ballroom dance,
Give yourself a chance,
The mighty King's Man.

╱皇家特工

長桌盡頭
大理石般的臉孔
魅惑的雙眼
利延德克的身體
你還可以更誘人麼？
滲出一絲恐懼
你正在出任務？
一個祕密會面
若我知道
你在扮鎮定有型
看著你看著我
我們會是天作之合
給自己一個機會
邀我跳舞吧
高高在上的皇家特工

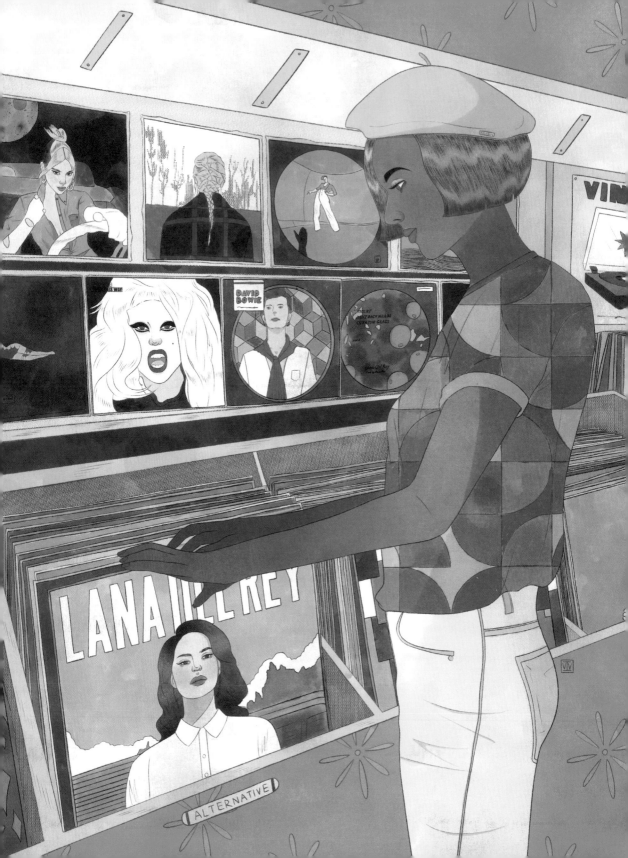

Record Store

They said music carries memories,

A series of memories that are categorized into boxes.

I have a few collections of vinyl records,

Ones that are hanging beside my bed.

I play Lady Gaga when I wanna dance.

Dance like a monster,

Wishing I was stronger,

Singing Born This Way,

Proud to call myself gay.

You said we are going to watch House of Gucci,

But then we broke up,

Saying you don't want me.

I play Lana Del Rey when I feel sad.

You said you love her,

And your favorites are Born To Die and Summertime Sadness,

I laughed and asked that's all?

There should be a whole lot more.

Unlike my friend Jeffrey who always asks me to play Chemtrails Over The Country Club at parties,

I do it deliberately,

To feel sorrow.

Cause I like to picture myself in the world she creates,

Protagonist of the tragedy play.

Here it is,

Violet bent backwards over the grass,

The audio record of her poetry book.

Poems full of hope,

Lana's voice is music,

As if everything in this world can be fixed.

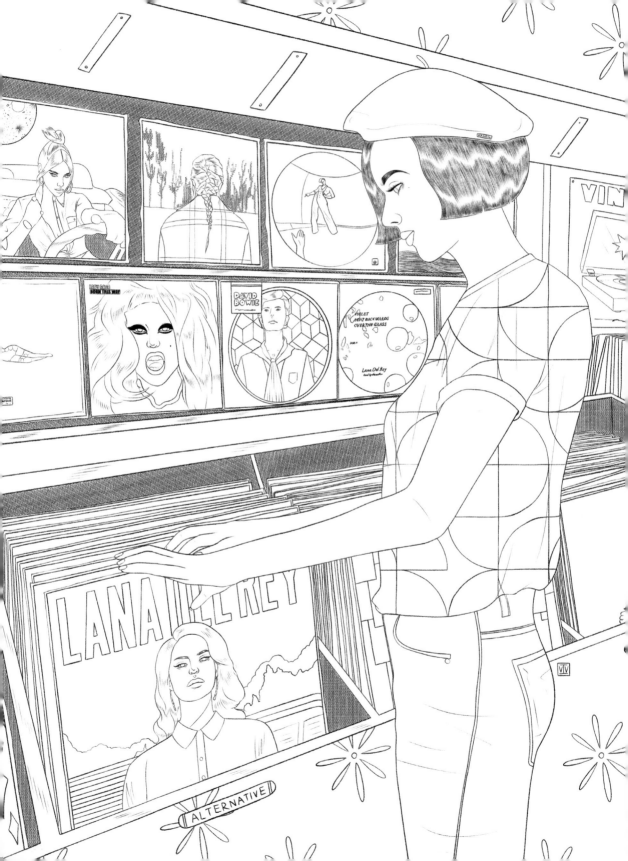

╱唱片鋪

大家都說音樂伴隨記憶

一連串的回憶分門別類

放進無數個盒子

黑膠唱碟的收藏

我懸掛牀邊

跳舞時放 Lady Gaga

像妖獸般舞

要更堅強

就高唱 Born This Way

驕傲宣告：我是同性戀

約定去看 House of Gucci

但我們分手

你說你不愛我

悲慟時習慣放 Lana Del Rey

你也喜歡她

最愛是 Born To Die 與 Summertime Sadness

我嘲笑：就這樣？

應該還有更多

不像我的朋友總是在派對上叫我播放 Chemtrials Over The Country Club

我是刻意放的

只為浸淫在悲傷

總愛幻想

我是她創造世界中的

悲劇主人公

來了

紫羅蘭倒臥綠草上

她詩集的聲音記錄

句句是希望

在 Lana 的歌聲下

彷彿世間一切皆可療癒

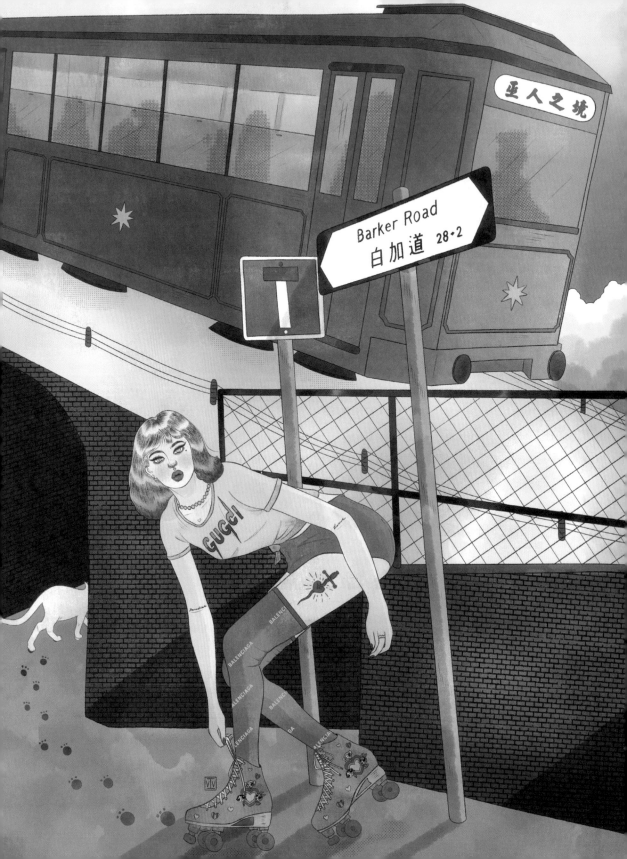

Rolling In The Deep

Meow.

The black cat's tail flickering into the alleyway,

I rolled uphill,

Tram shifted downhill,

Am I rolling in the deep?

Is this the rabbit hole?

Or cat hole?

My name isn't Alice,

This isn't Wonderland.

I don't like this,

Is there even solid ground?

Will I be safe and sound?

At least make this one count.

／墜

喵。
街巷尾搖晃著黑貓尾
我向山上碌
車往山下走
墜落深淵？
這是兔仔洞？
還是，貓仔洞？
我不是愛麗絲
這也不是仙境
我不喜歡
這樣
地板還存在嗎？
我還安全嗎？
至少讓我記著吧

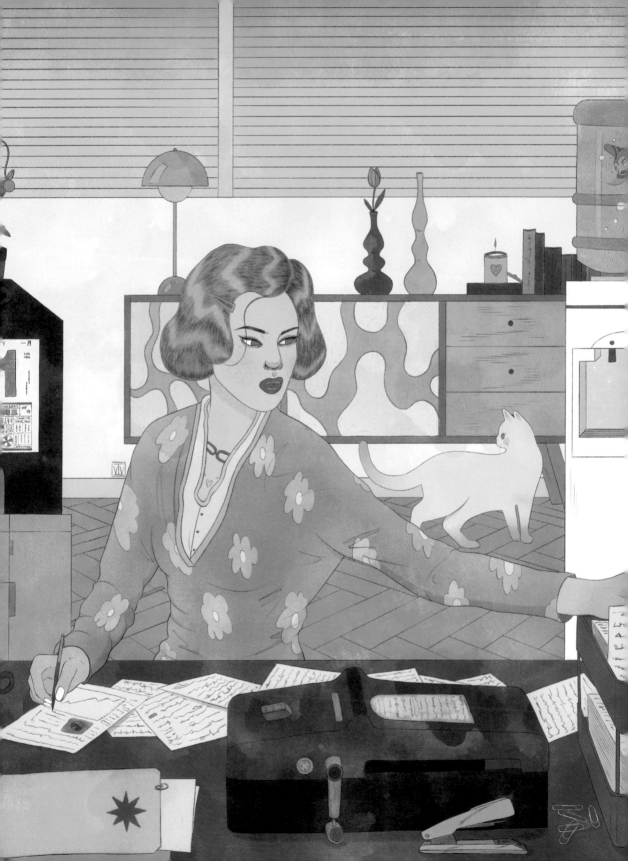

9 to 5

Before I became an artist,

I was an ordinary office worker,

Working 9 to 5,

Earning a tiny bit hoping I can survive.

I'm not Dolly Parton,

Can't act like I'm holly jolly about it.

I hated my job, hated that I'm doing nothing special.

I was a graphic designer,

Not a very skillful one,

A tour guide for a wax museum,

Looking at lifeless figures as if I was one of them,

A not so qualified photographer,

Always using the auto mode,

When will my time come?

I even secretly draw on paper when my boss is not watching me,

Full of arguments and disagree,

I was fired from every full-time job.

And then one day I make it,

Years of efforts are finally worth it,

Bit by bit,

I was walking towards the dream,

Being seen at last.

I'm now on the cover of magazines,

Working with celebrities,

People envy me,

It's never easy,

You have to work really hard,

The path may be dark,

but as long as you have your sparks,

You'll eventually hit your mark.

／朝九晚五

成為藝術家之前
我是個朝九晚五的打工仔
依靠微薄人工過活
我不是桃莉巴頓
我不懂仿製快樂

厭惡這份工作
厭惡這種平庸
我曾經
是圖像設計師
但技藝不精
是蠟像館導賞員
凝視那人偶就像
毫無生氣的我
是半桶水攝影師
只管啟用自動模式

我的時刻何時到臨？
沒有上司的目光
在紙張上祕密作畫
伴隨爭執與反抗
落入失業的境況

直到有一天，我成功了
沒有白費多年努力
一步一步
我走向夢想
走入眾人目光
雜誌封面
與明星合作
容易招人妒忌
但這從不容易
我必須竭盡全力
前路黑暗但光芒難禁
終會成就你的初心

62

5:12 pm

Dust specks lit by afternoon, golden as it was.

Broken trust,

Forgotten stuff.

Searching for my lust for life.

午後浮塵金黃如昔

被破滅的承諾

被遺忘的角落

永恆的，追逐愛慾

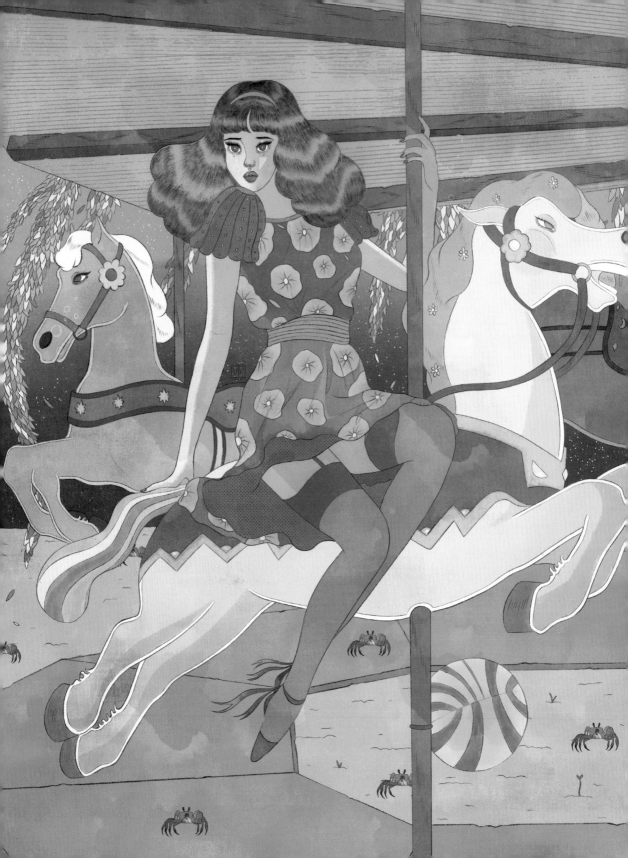

Merry Go Round

I have a tarot card with the illustration of a merry go round,
But it wasn't like the typical ones you see at a carnival,
Circling around with tamed horses and flashing light bulbs,
Enchanting music makes you feel safe and sound.

Derailing, the horses start to be unsettled,
Like a burning water kettle,
Fighting to get off the rails and find its own path.

I'm not the one who followed a path and be satisfied if I'm running in circles,
I strived to break the cycles,
Like a speeding train breaking through the final destination.
That's my dedication,
My dedication to my career,
My dedication to life.

／旋轉木馬

我有一張旋轉木馬圖案的塔羅牌
但不是嘉年華裡那一種
回轉的溫馴小馬與點點閃燈
配上安穩舒適的柔和音樂

脫韁野馬渴望飛騰
像水壺沸騰
掙脫束縛你的軌道
是尋覓自我的路

我不會為循規蹈矩而自滿
若被困在一個迴環
我矢志打破循環
似一輛衝破終站的列車
對事業與生命的承諾
我永不割捨

69

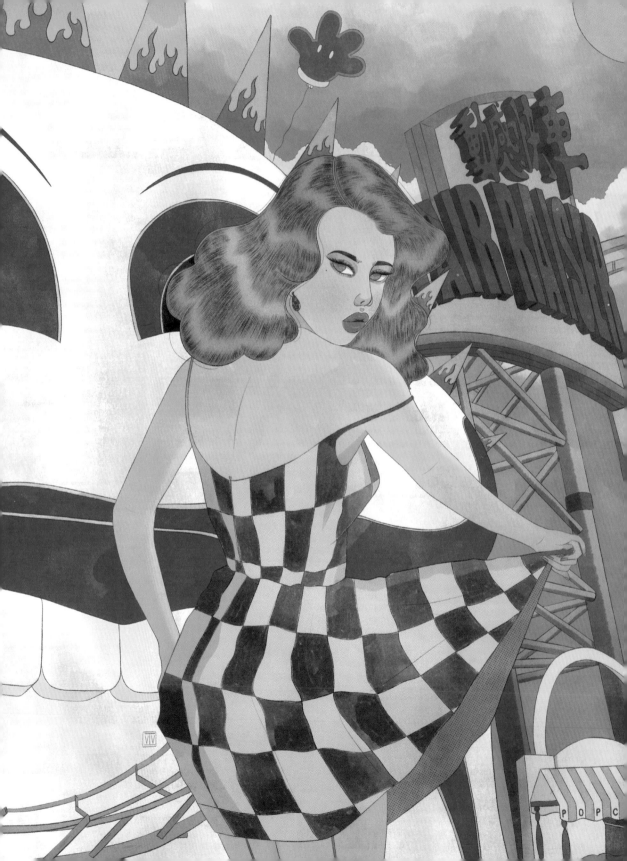

Roller Coaster

Clown head thriller ride,
Hair raised like my heart rate,
Is this a date?
Hold my hand,
Walked into the gate,
Not afraid about the height,
But looking straight into your eyes.
360 roller coaster,
Pulled my heart closer.
Chilling wind in October,
I wished this ride could go slower,
This moment is forever,
So I can sit next to you longer.
Butterflies in my stomach,
Bellyaching,
Hands shivering,
Thoughts puzzling.
Up and down,
The tension is drowning me,
Back to the ground,
Can we go for another round?

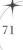

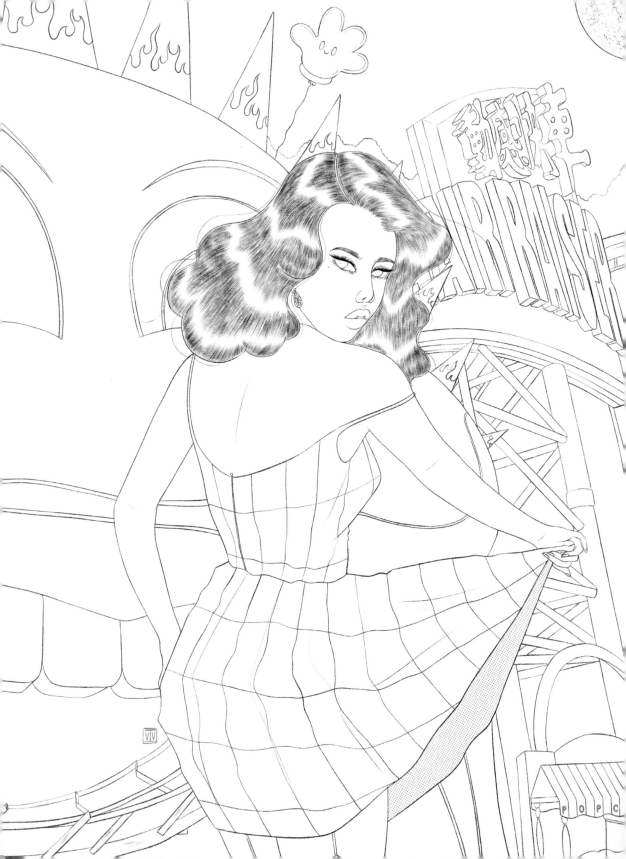

／過山車

小丑頭帶領的驚悚遊戲
頭髮隨心跳攀升
這是約會嗎？
緊握我的手，帶我走到閘前
我不懼怕高度
但懼怕直視你眼眸
三百六十度轉圈的過山車
緊繃心胸
十月涼風
我希望放慢車速
祈願此刻永恆
在你身旁多待一刻
漫天紛飛的
愛戀
腹痛
顫抖
凌亂
忽上
忽下
使我窒息的重力
然後，回到地面
不如再多來一遍？

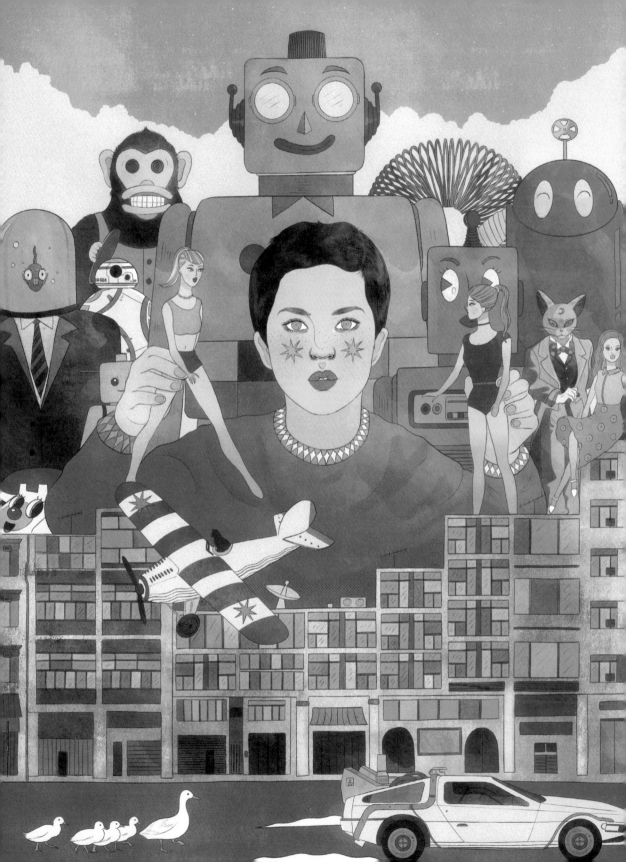

Wonderboy

Barbies, robots,
Why do I have to choose?
Both are fun,
Drawing suns and laser guns,
I'm done with picking sides,
A toy is toy,
Not labels for you to destroy.

This sacred heaven for them,
To create wonders and miracles,
All things bright and beautiful.

／小孩

芭比與高達
小孩才做的選擇
樂事成雙
畫太陽與雷射槍
我厭倦二元對立
玩具是玩具
不是標籤的工具

所有夢幻
一切美善
盡在這神聖的殿堂

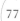

Ride

When I'm on the swing,
I endeavor to touch the sky,
So I ride harder and harder,
Higher and higher,
Till I reach the point.
Threshold.

Sometimes I wonder if I could go higher,
If I had someone behind my back,
Pushing me beyond my threshold.
But the point is,
The force of an external push, is you.
Trust yourself and don't look back,
The North Star will be touched.

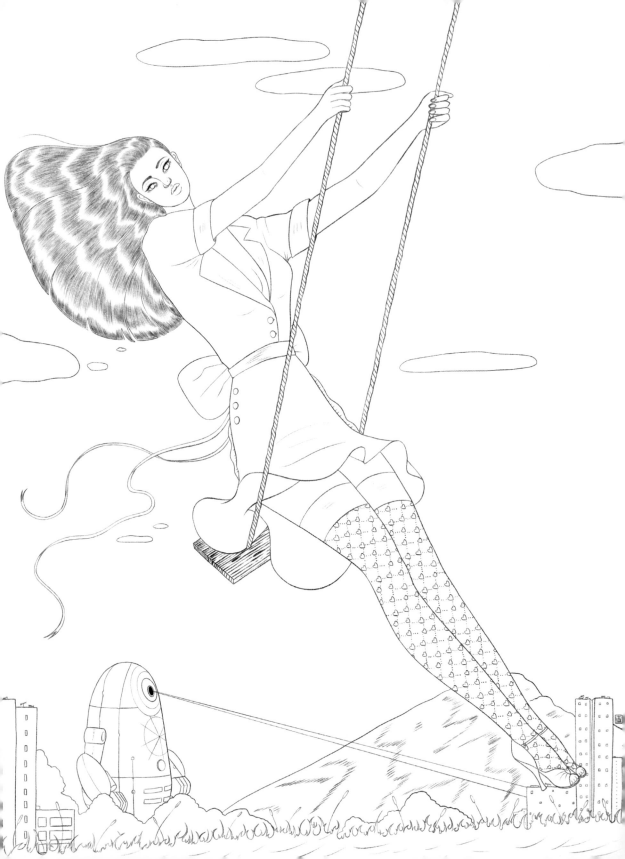

／旅

在鞦韆上
我誓要觸碰天空
竭盡全力
盪得更高更高
直至指尖碰上
瓶頸

有時我想
若有人在身後
推我一把
會否衝得更高
但現實是
背後只有你
相信自己，不要回頭
你會碰到北斗星

Soft Ice Cream

Soft ice cream,

Silk-like dream,

This tastes like a memory that I've had.

Walking through the waterfront promenade,

Wide-eyed gaze,

Mist of haze.

I thought is this it,

Sweet gentle kiss,

The moment we miss or did we?

I tried to be cool, to be the coolest,

Petals fall, picking true or false,

Not knowing if you like me or not?

Oh god you are the one I wanna taste,

Not the vanilla milk ice cream,

Not the crispy cone,

Woke up and realized I'm all alone.

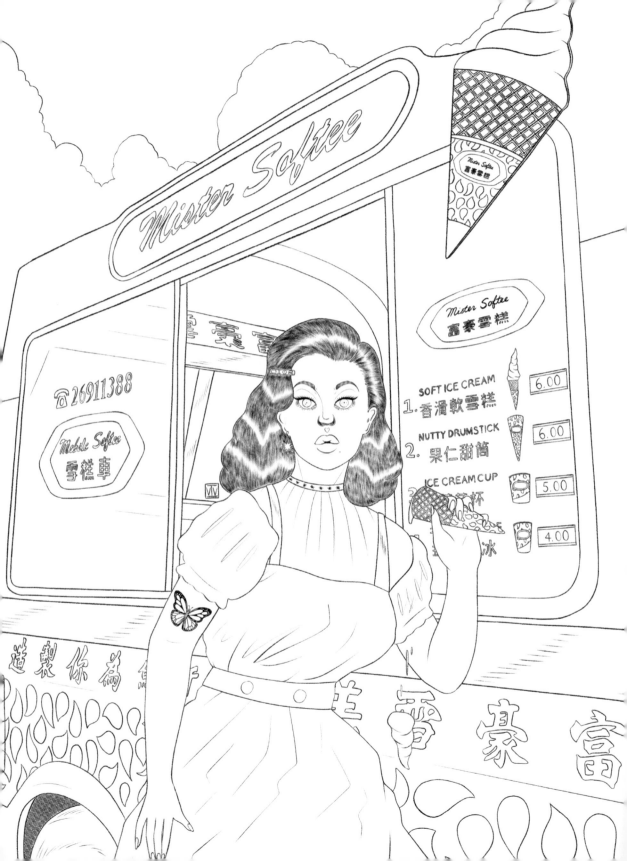

╱軟雪糕

軟糯似雪
柔順似夢
味蕾上的記憶
走過海濱長廊
凝視眼前迷霧

我想就是這裡
一個溫柔甜蜜的吻
一個錯失的緣機
錯失？
我要很酷，成為最酷
花瓣墜落
翻起對錯
誰知你是否喜歡我？
不要軟雪糕
不要脆甜筒
只要你

驚醒
獨自一人

6:23 pm

Sunset by the sea,
Coastline disappears.
Shadows cast by trees,
Dropped a single tear.

海邊夕陽
地平線消亡
樹林影子
落下一顆眼淚的漣漪

The Carnival is Over

Remember the teddy bear you won for me?

The promises that you guaranteed.

Sweet like a fairytale,

Until you left me and it hurts like hell.

I wrote you a long letter,

Do you still keep it?

Or you didn't even read it.

You said we're just having fun in the meantime,

And that's just a crime,

You were never truly mine.

The next week I went back to the carnival,

Mid October,

But it's already over,

No more roller coaster or ring thrower,

Like nothing ever happened.

Vanished into thin air,

The circus that was once there,

Not even the booth hanging my teddy bear,

Lights, camera, action,

Polaroid that we took has faded,

Faded into black and white,

Films in history,

The end of the story.

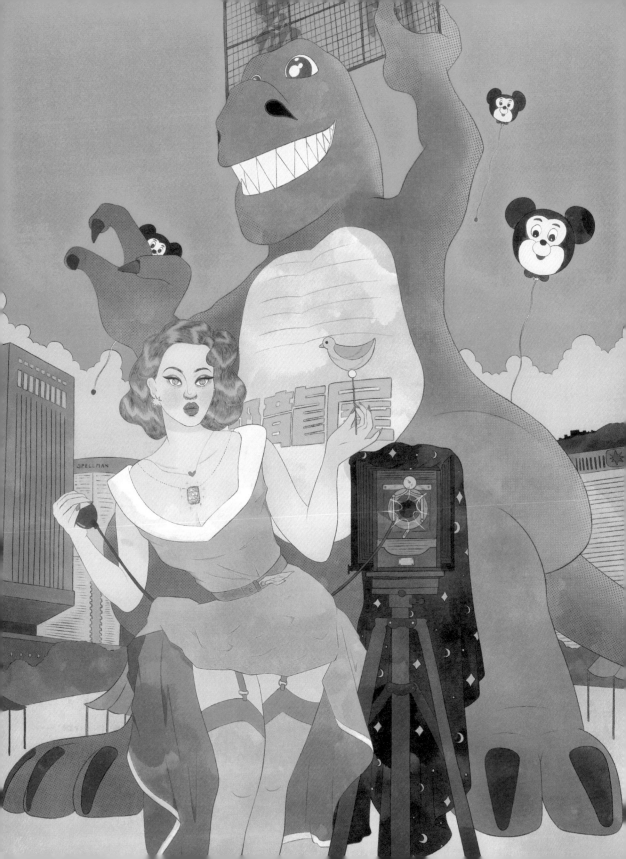

／嘉年華的結束

記得你為我贏得的泰迪熊嗎？
無數承諾，甜蜜似童話王國
你的離去，讓我心如刀割
我寄給你的長信
你還有保留麼？
抑或你根本沒有讀過？
你說只是遊戲一場
你從不屬我

之後那星期，我回到嘉年華
十月中旬，它早已完結
過山車與套圈圈消逝
在涼風之中
就似一切不曾發生
馬戲團與人龍
在攤檔懸掛的泰迪熊
三、二、一
褪色相紙化成黑白
已結束的故事

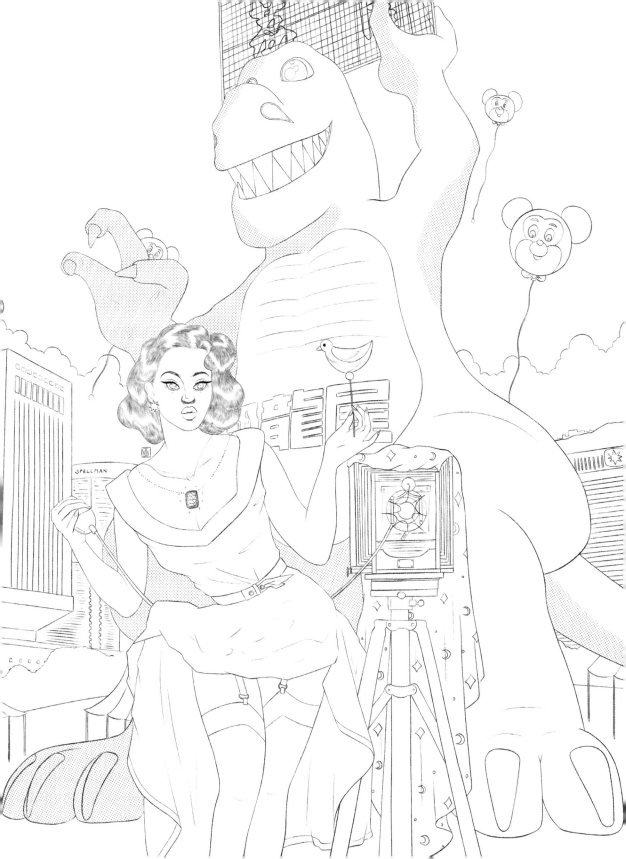

Bubble Magic

Bubbles bursting into sparks,
Sparks transcend into dreams,
Dreams long lost become flashbacks,
Vintage films,
Reminiscing the fond memories of youth.
Sweet like strawberry cake,
Today, I am eight.

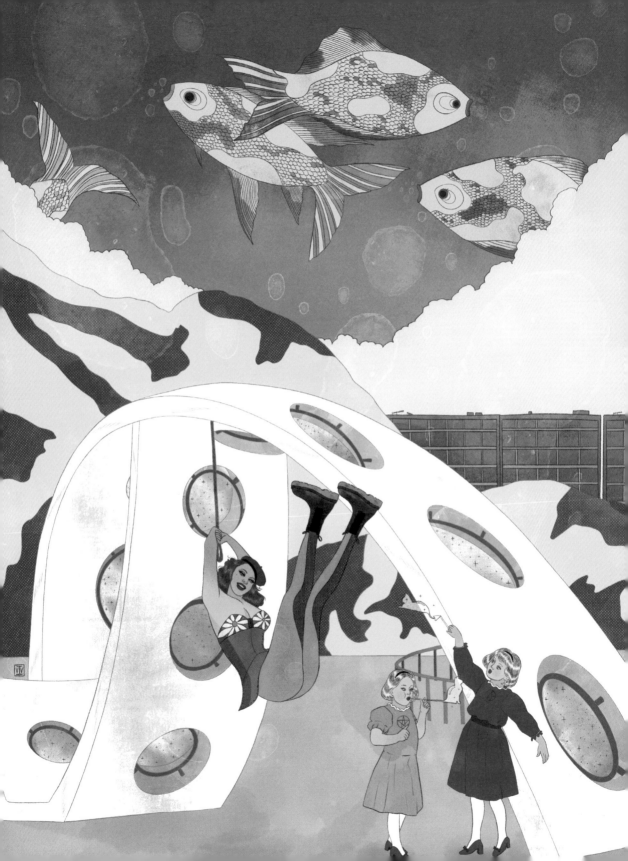

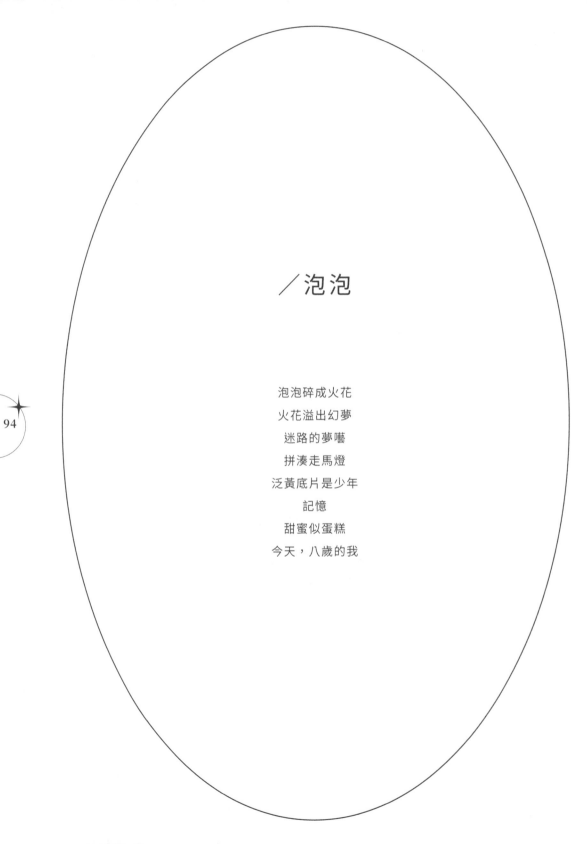

／泡泡

泡泡碎成火花
火花溢出幻夢
迷路的夢囈
拼湊走馬燈
泛黃底片是少年
記憶
甜蜜似蛋糕
今天，八歲的我

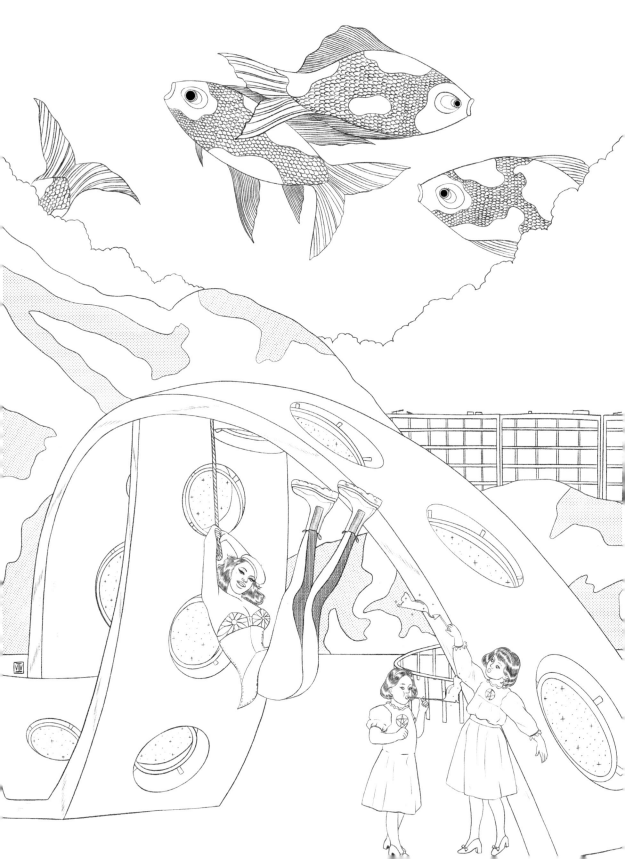

Somewhere in Time

Sometimes I wonder where does this necklace come from?
Maybe somewhere in the 80s?
Pretty.
There's something mysterious about vintage items,
Maybe some celebrities wore it in the 90s?
Pretty.
Somewhere in time, fine jewelries, sparkling diamonds, black pearls,
I want to wear it all.

If only I could travel back in time like Richard Collier,
Back to the glamorous eras,
People wearing thick mascara,
Staying at Hotel Riviera,
Dance like Cinderella,
There's beauty somewhere in time.

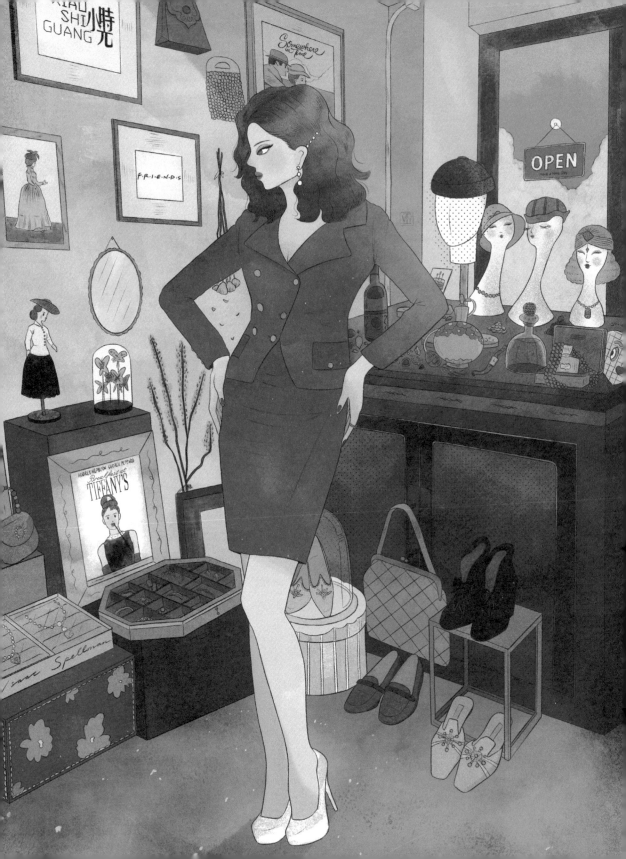

／某處時空

有時我想，這項鏈從何而來？

八十年代某處？

很美

復古物品有種神祕

在某個九十年代明星的頸上？

真美

某個時空的，精緻珠寶，閃耀鑽石，黑珍珠

我渴望戴上一切

若我可像 Richard Collier 般穿越時空

回到那絢麗年代：

人們塗上厚厚睫毛膏

在酒店大廳跳灰姑娘的舞

時空某處

存在某種美麗

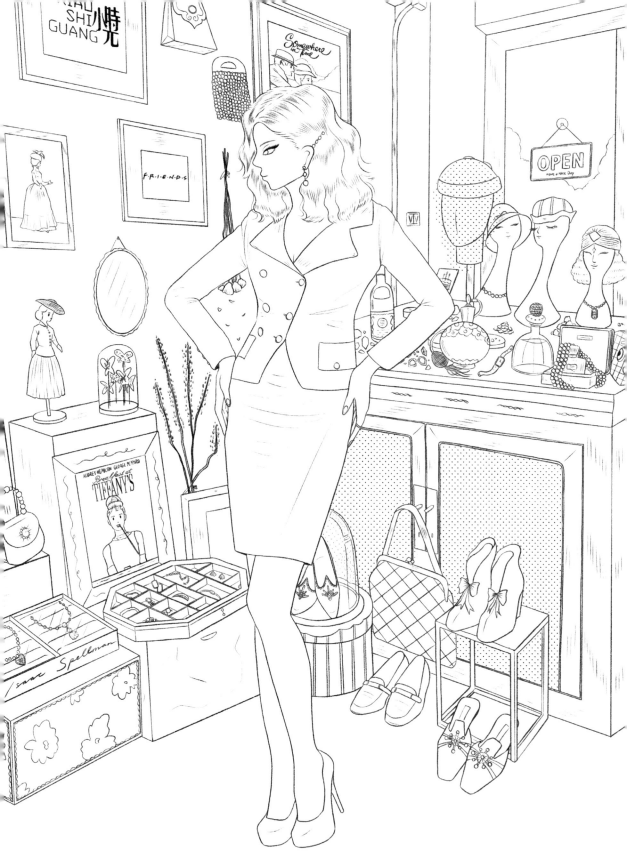

Finding Nemo

I used to go to night markets when I was a little child,

And the catching fish stall always captivates me.

If I was lucky, I would have three to five new pet fishes in my tank.

But they always died in a few weeks,

Just like my love life.

It's already hard to find the one in the vast wide ocean,

Just like finding Nemo,

It's mission impossible.

I'm not the perfect master of pet,

I don't know how to make them feel happy.

They make me laugh but I can't do the same.

They all went by different names,

Mr. A, J & F.

Sorry, I didn't take much care of you,

Sorry, I let you die and sink in the tank.

I'm sorry I don't know how to love.

Empty and blank.

Sorry.

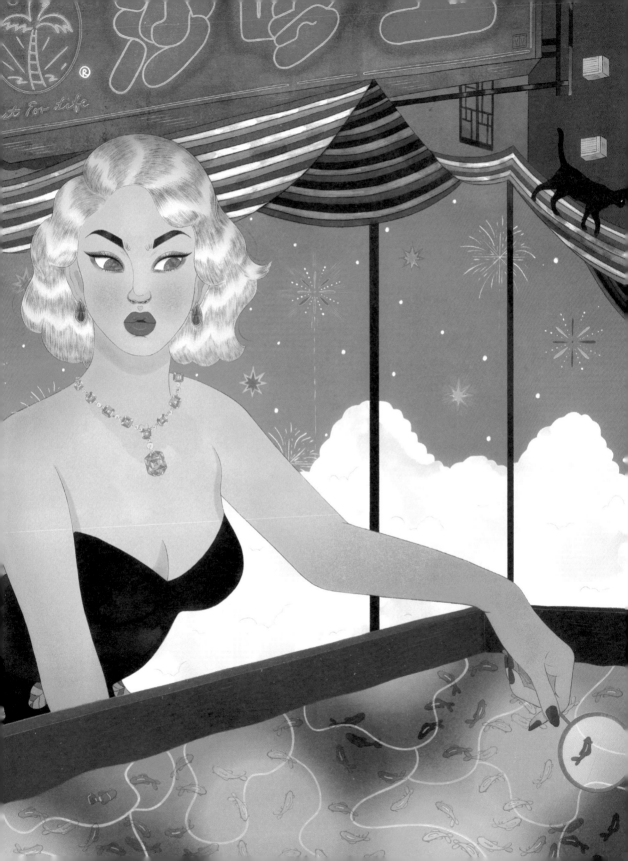

∕缸底奇兵

我小時候愛去夜市
撈金魚的攤檔很吸引
走運時，為魚缸添三五條新寵
但牠們只有數週壽命
如同我的愛情
茫茫大海難尋愛侶
就像馬倫搵 Mo 仔
不可能的任務

我不是完美主人
不懂為他們帶來快樂
他們給我的歡笑，我無以回報
Mr. A、J 和 F，他們有著不同的姓名
抱歉，沒有好好照顧你
抱歉，任由你沉溺缸底
我悔恨我不懂愛
空洞與空白
對不起

Mer Bleue

Mer is sea in French,

Is that why mermaids are called mermaids?

Body made of water, beautiful creatures,

Siren voices lure men into the sea,

Like how you lure me into your sweet talk.

You are pretty and charismatic,

But when you lose control you're psychotic.

Flirting with everybody,

Touching everybody,

Fooling everybody.

I was searching for love but all I found were mermaids,

A mirage of love,

Am I too nice?

To not be taken seriously.

I don't paint my art blue,

It'll just remind me of my sadness,

I look at the blue sea,

And all I see is the lonely reflection of me.

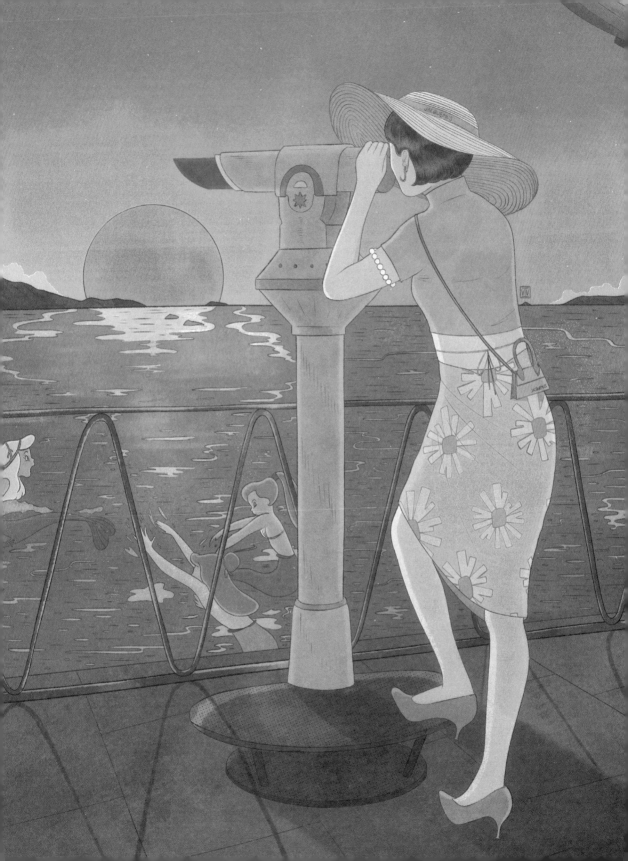

╱海洋藍

Mer 是「海洋」的法文
因此「美人魚」就是 Mermaid?
身體水造的唯美生命

海妖輓歌
引誘水手墜入海洋
一如你的甜言蜜語
平時美麗誘人
失控時是神經病人
調戲所有人
愛撫所有人
欺騙所有人

我苦尋愛情
卻一再墜海
愛的假象
我是否太軟弱?
無人認真待我
我作畫從不用藍色
不欲傷春悲秋
每當我凝視蔚藍海景
我只見我的孤獨倒影

9:03 pm

Every single time I close my eyes,
Lonely nights.
Empty dining table,
The air was dreadful,
All I seem to think about is you.
Damn you.

每當我閉上眼
都是寂寞夜晚
餐桌空無一物
空氣死寂
我的思緒，全都是你
他媽的

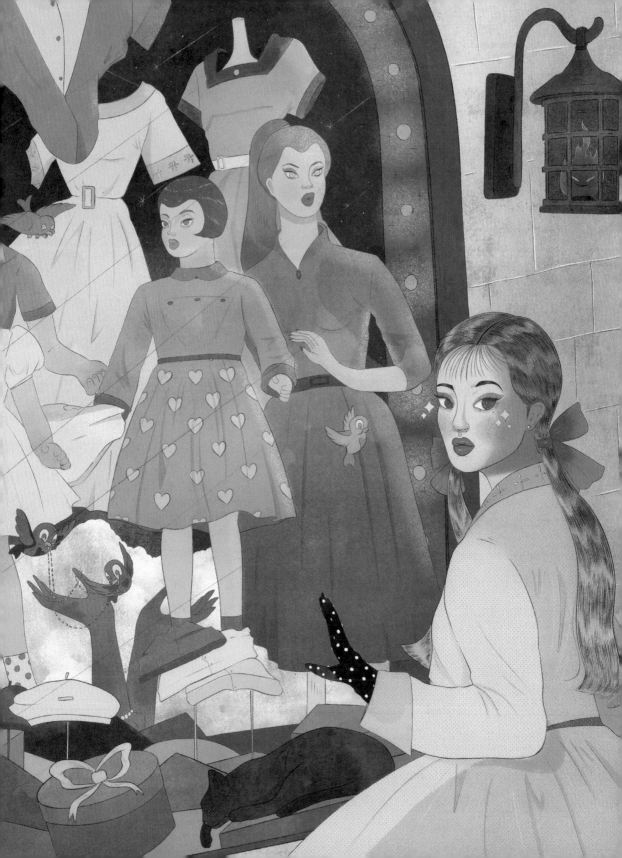

Magic Shop

There's a kind of magic called Gucci,
All kinds of items, shiny and pretty.
Renaissance history reflects your inner beauty.
I was born to wear Gucci,
Born to be weird.
When I walk into the magic shop,
I feel like walking into my version of heaven,
Sparkling decorations and glittering patterns,
I dress up to be a stronger version of myself,
More mysterious and charming.
Go to a party, coming hot.
Can you handle it?
The embodiment of cool.

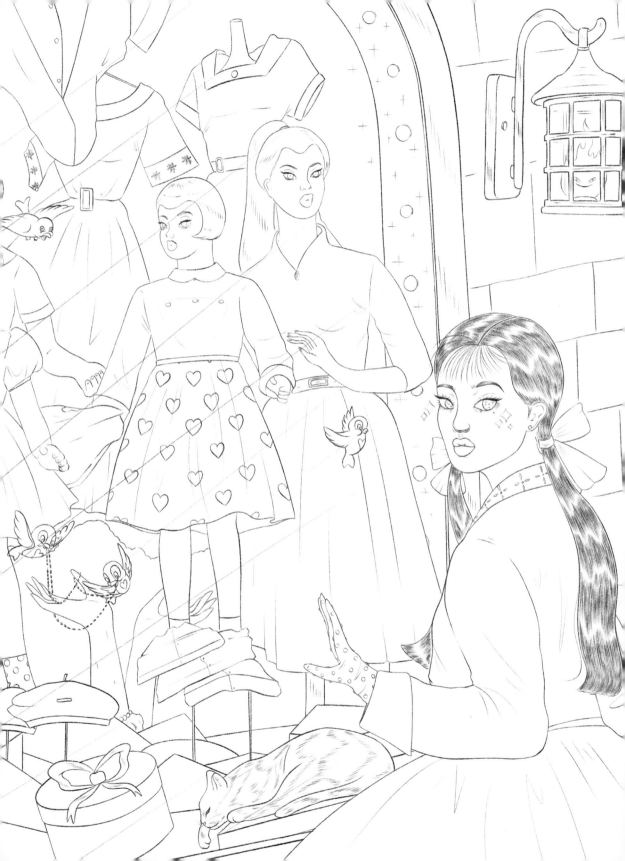

／魔店

有一種魔法叫 Gucci

琳琅滿目的精品

文藝復興映出內在美

我因 Gucci 而生

我生而古怪

每當我走進這魔店

如步入我的專屬天鄉

閃亮裝飾與花紋

我穿上更強大的自我

神祕而懾人

闖進派對現場

敬請預備心神

迎接酷的化身

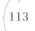

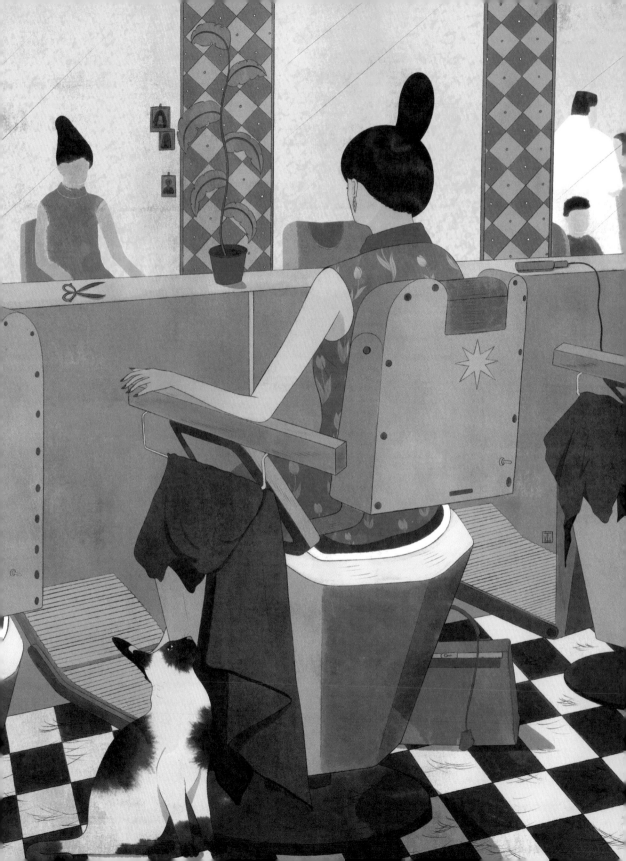

Hair Salon

Don't ask me to cut my hair,
I feel free and cool in my locks,
Look strange at me,
Whatever,
Like I even care,
My looks totally rock.

The hair salon is where I belong,
That shy old kid was long gone,
Did think about going blonde,
Fantasized about being Rapunzel singing songs.

I did crave a lover's touch,
Washing and blow-drying my hair,
Lying my head over his thighs on the couch,
Love flares lighting up the living room,
Beautiful blue cornflower eventually blooms.

Heaven is a place on earth.

╱髮型屋

不要叫我剪髮
自由奔放的辮子
來吧！怪異目光
我毫不在意
我看起來無懈可擊

髮型屋是我的歸宿
再會了，羞澀一族
染上金髮不再木獨
如長髮公主以歌聲征服

我渴求戀人觸碰
洗擦再吹乾我的髮
躺在他大腿上
愛火點燃了這個家
綻放出藍色車輪花

此時此地，就是天堂

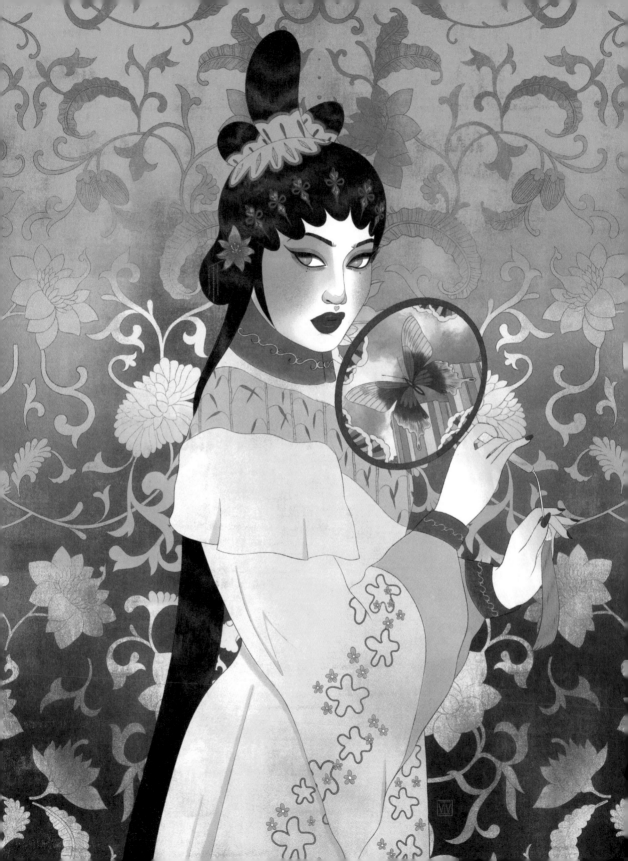

Opera

Classic tales told on the stage,
Heart-wrenching dialogues written on pages,
Unfamiliar languages,
Trying everything to bring a new change.

This ain't the Phantom of the Opera,
It may not sing like Frank Sinatra,
But it's an absolute mesmerizing genre.
Heavy makeup and costumes,
Singing under the moon.

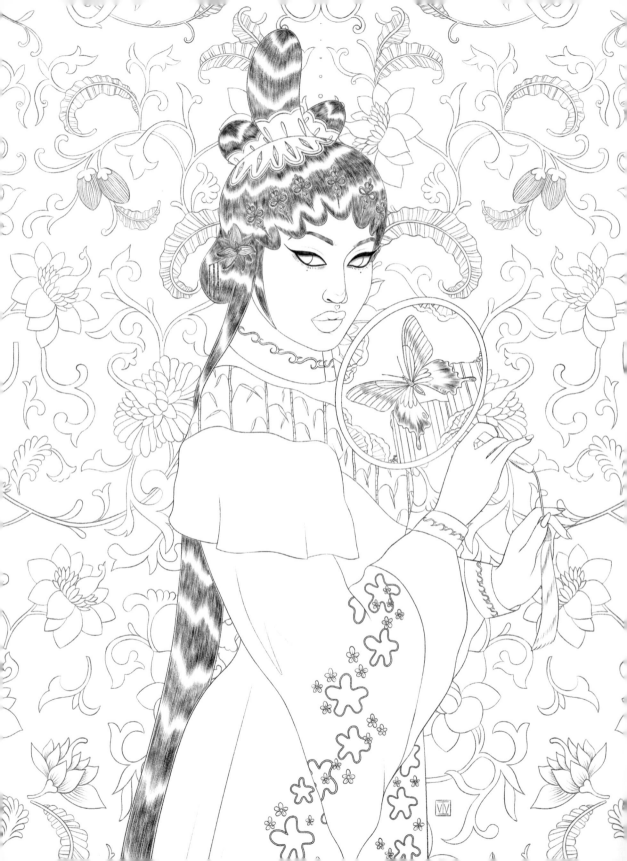

／歌劇

舞台上訴說經典故事
扣人心弦的劇本台詞
陌生語言
勇於嘗試帶來改變

不是歌聲魅影
不如仙納杜拉動聽
但的確引人入勝
濃妝美衣
月下鶯歌

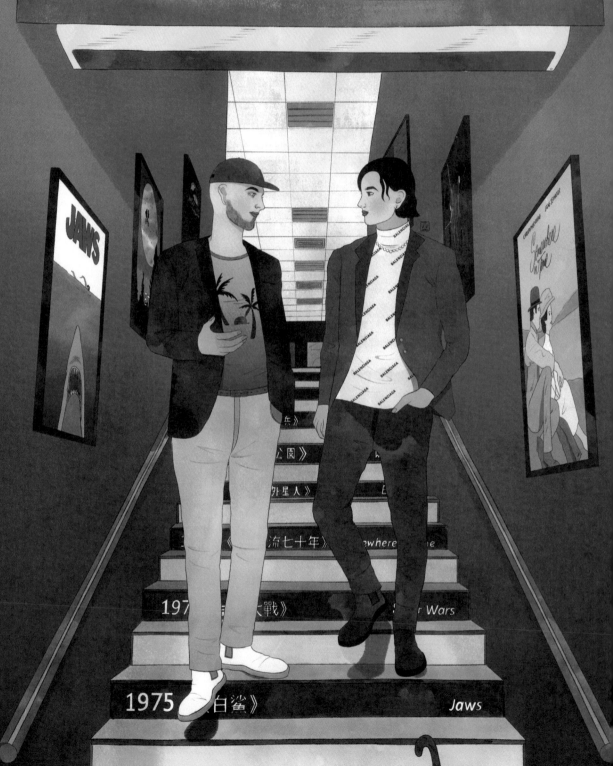

Lust Theatre

I can't remember your name,
But I do remember the pain.
I can't remember the movie,
But I do remember how you kissed me.
You said you fly in the sky,
Serving women and guys,
Even your look makes me shy.
Blue eyes like James Dean,
Thick lips like Marilyn,
Fucking teenage dream.

We bought tickets at the last moment,
Sitting at the end of the line,
Legs sore after hiking a mountain,
Holding your hand like you were mine.
You buy me dinner and tell me you are vegetarian,
But it's time,
Time to say goodbye,
Thinking I might not see you again makes me wanna die.
So you kiss me on the lip,
Like a final touch of this trip.
Can't help but want more,
You do too.
Hotel room my heart blooms,
Heaven is a place on earth with you.
You ask me to stay,
I said not okay,
My mum would worry about what I'd been doing the entire day.
We hugged and said goodbye,
Can't help but cry,
Cause I'm not fine,
Silly me thinking this is love.
Sweetest Sweden I ever knew,
The only few ones that make me feel.

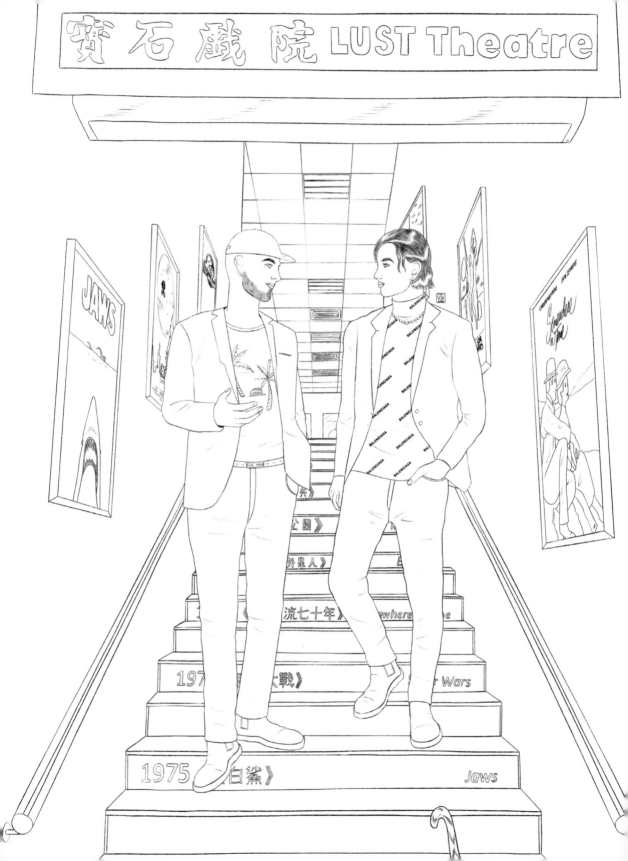

／情慾劇場

我忘了你的名字
但記得那份痛
我忘了戲名
但記得你的吻
你說，你在空中飛翔
服侍男男女女
你的臉孔讓我羞澀
藍色瞳孔，似占士甸
厚厚嘴唇，似瑪麗蓮
該死的少年春夢

在最後一刻買票
在最後一行坐下
是遠足後酸軟的雙腿
我緊握你的手
像擁有你的一切
你請我吃晚飯，說你只吃素

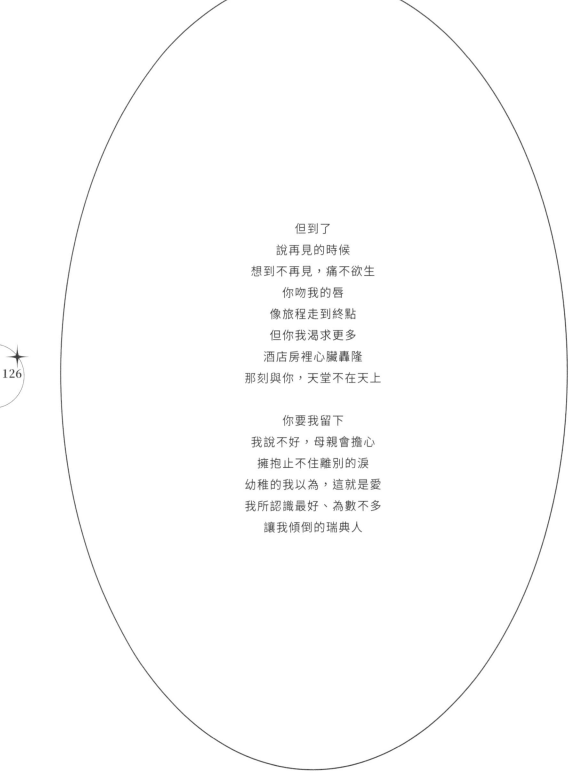

但到了
說再見的時候
想到不再見，痛不欲生
你吻我的唇
像旅程走到終點
但你我渴求更多
酒店房裡心臟轟隆
那刻與你，天堂不在天上

你要我留下
我說不好，母親會擔心
擁抱止不住離別的淚
幼稚的我以為，這就是愛
我所認識最好、為數不多
讓我傾倒的瑞典人

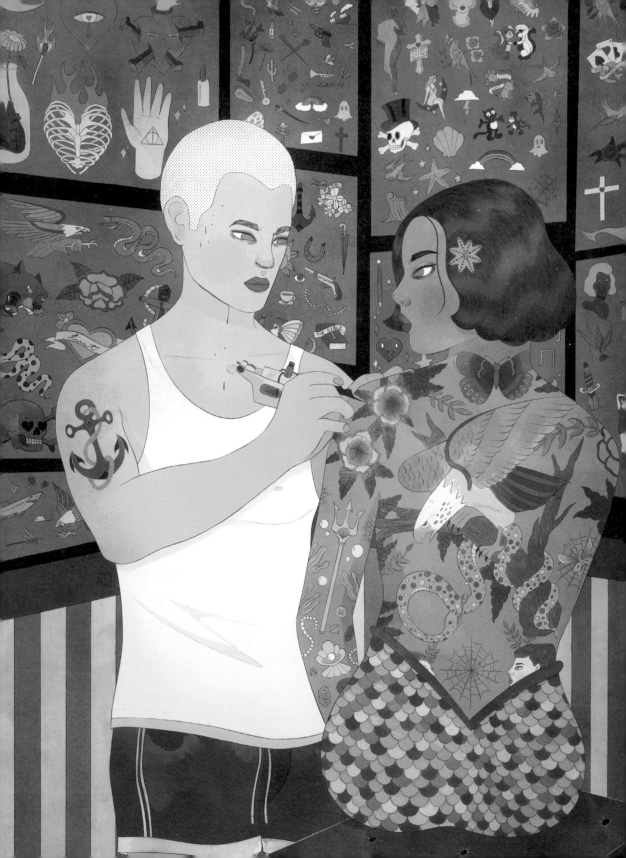

My Name on Your Tattoo

Counting the tattoos on your arm,
The double fishes reflect your Pisces's heart,
Arm hair raises when I touch you.
You always have a sweet mouth,
Pointing stars from South to North,
Fireworks sparkled in your eyes like the Fourth of July.
You joke about having my name on your future tattoos.
I laughed that's not something you can undo,
Tattoos speak about the truth.
You are the wildflowers,
Uncontrollable and unpredictable.
Words coming out of your mouth,
I'm captivated by you without a doubt.

Dying roses, fire-burning skeletons,
Shooting guns, flaming sun,
You have all those over your pale and skinny body,
Leather jackets embroidered "Cali",
There's already no space for another name,
The once clean skin is now full of inks,
Like a blank canvas being spilled with black paints.
Your past is written over by new chapters.
I know you are trouble but I can't help walking towards your deathtrap,
Like a moth flying into the fire,
Body disintegrates in a snap.

Who am I to you?
How can you say such things that shook my heart?
I'm not that smart,
I can't see through the chaotic mind of yours,
I'm not a gangster,
Following your orders as if you were my master.
I need an answer, answer me,
Do you really love me?
Or am I just like the others?
Fling in the summers,
Winter comes,
Autumn goes,
Spring arose,

Do you still feel my name on your skin?

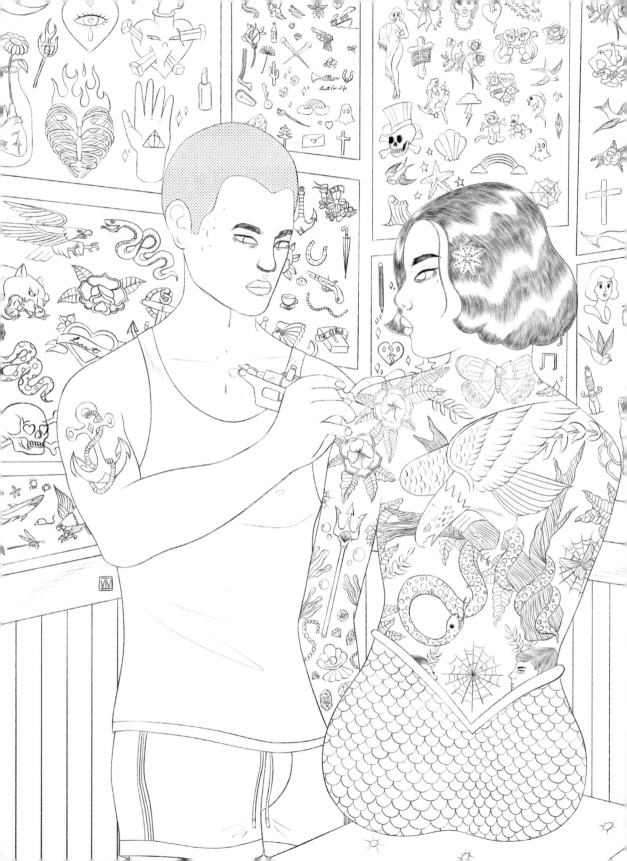

╱我的名字你的刺青

細數你臂上刺青

雙魚圖案映出星座靈魂

我的觸碰使你汗毛直豎

你一向口甜舌滑

南至北指遍天上星斗

眼眶裡煙花燦爛

你說笑要紋上我的名字

我笑說這是終身的事

刺青細語真相

你是野花

不受操縱，不被預測

你的話語，深深吸引我

凋零玫瑰，燃燒骷髏

開火長槍，熾熱太陽

盡在一副慘白瘦弱的身體

繡上「Cali」字樣的皮褸

已失去可寄宿另一名字的空白

純潔皮膚如今佈滿墨水

空白畫布上揮灑黑彩

以全新篇章掩蓋陳年往事

我知你是個壞男孩

但仍情不自禁墮入陷阱

像燈蛾撲火

瞬即灰飛煙滅

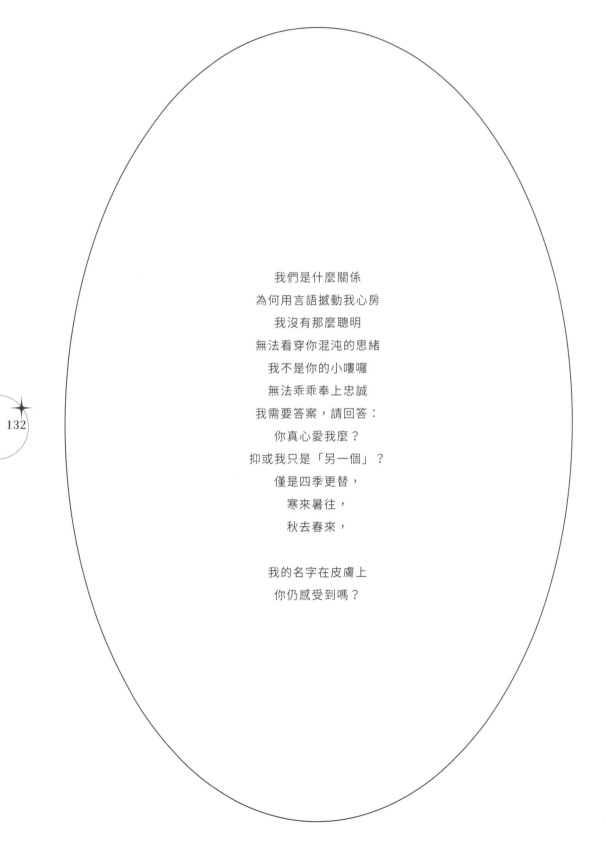

我們是什麼關係
為何用言語撼動我心房
我沒有那麼聰明
無法看穿你混沌的思緒
我不是你的小嘍囉
無法乖乖奉上忠誠
我需要答案，請回答：
你真心愛我麼？
抑或我只是「另一個」？
僅是四季更替，
寒來暑往，
秋去春來，

我的名字在皮膚上
你仍感受到嗎？

2:14 am

Now I just wanna stay here,

Falling into midnight.

Hug me in your arms real tight,

Want nobody else now,

Only you,

Feel right.

此刻

我只想留在這裡

隕落到午夜

緊抱我到滿瀉

我不要任何人

除了你

I Think We're Alone Now

I used to imagine this scenario a thousand times,
Practice makes perfect,
I want it but don't know what to do next,
Guide me and make me feel good about it.

I think we're alone now,
There doesn't seem to be anyone around,
The beating of our hearts is the only sound.
Body shivers, hot like fever,
Taste like cherry cola,
First kiss cherishes forever.

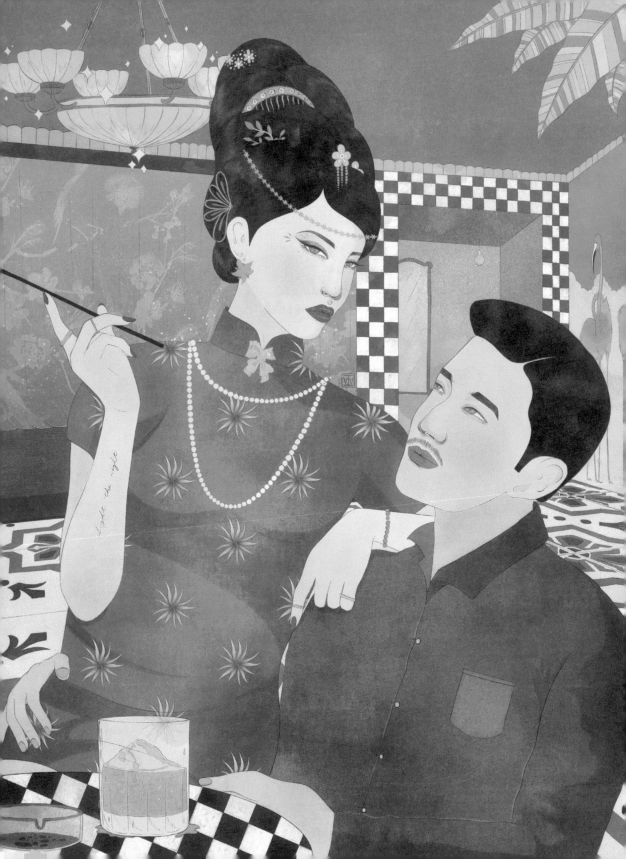

╱獨處

我時有幻想此情此境
熟能生巧，
我渴求但我不懂追求
請你帶領我享受

獨處時光
無人阻隔
我倆的心臟節拍
全身顫抖，熾熱似高燒
櫻桃可樂的滋味
永遠珍重的初吻

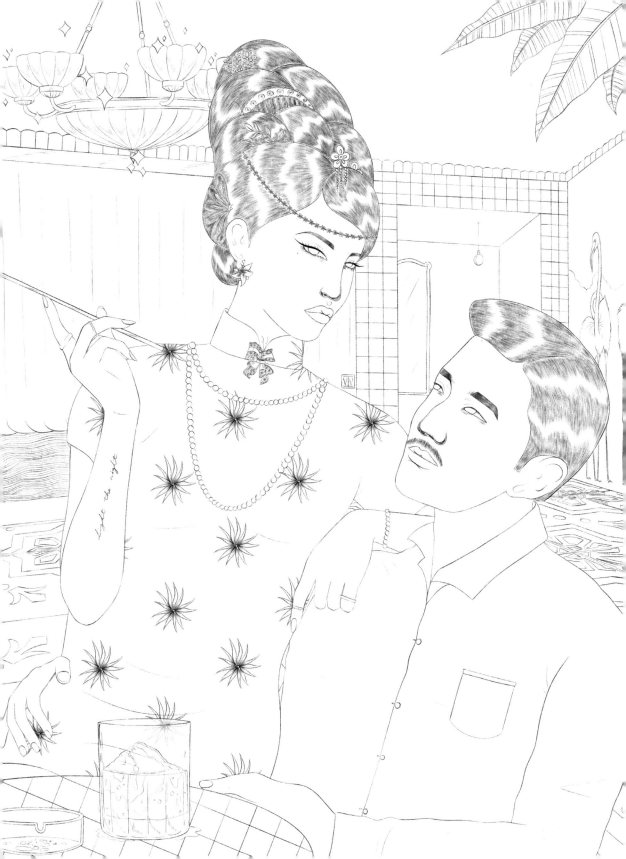

Dirty Laundry

Doing my own laundry,

And then you come in,

We look into others' eyes with chemistry.

Washing machines rolling, signals crossing,

Would we kiss like Ross and Rachel?

I want you to do dirty things to me,

Take off my clothes,

Heart bloom like roses,

How was I supposed to know?

You will someday let me go,

I still remember how you say hello,

seems like million years ago.

Let the dirty water wash all over me,

Make me dry and clean,

Turn off the washing machine,

Bittersweet tangerine,

Sometimes my clothes still smell like you,

Like you never leave me,

Leave me alone,

I still remember your number on the phone,

Stopping myself to drunk text you,

Acting I'm cool the other day I bumped into you,

Self-inflicted pain,

You're driving me insane,

The smell that never wears off,

In that pile of dirty laundry.

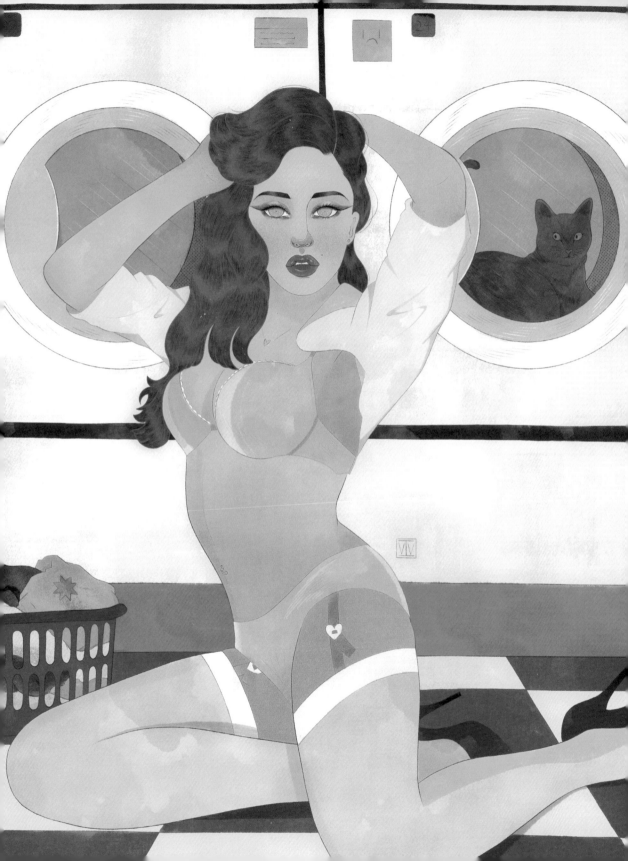

╱洗衣

在洗衣鋪洗衣服

然後你走進來

與我眉來眼去

滾筒轉動，心神互動

我倆會否像 Ross 與 Rachel 般熱吻？

我想讓你糟蹋我

脫去我一切衣裝

我心如玫瑰怒放

我怎會知道

一天你會放手？

彷彿已過去億萬年

你的道別仍歷歷在眼前

讓濁水流過我身

使我潔淨清新

關掉洗衣機

甜苦混雜的柑香味

衣服氣味仍帶著你

就像你從未離去

剩我一人

念記你手機號碼

制止自己借醉來電

偶遇你那天裝作若無其事

自尋煩惱

你讓我瘋狂

永不褪散的氣味

就在那堆骯髒衣服裡

Fly Me to the Moon

When I was young,

I would dream of flying to every country, continent,

Across every ocean,

Wouldn't it be fun?

And in that dream,

There'll always be a man I love sitting next to me,

He'll fly me to the moon,

Dive deep in the sea,

If I asked.

And you came into my life,

Said you would bring me to shop in Milan,

To visit the Eiffel Tower in France,

To let the wind sweep through our faces in Sicily,

Though now it sounds silly,

Cause none of them happened.

You lost all of the passion,

The passion we used to enjoy.

Till we become friends again,

And everything was destroyed,

Don't even want to play pretend.

Withered violets lying dead.

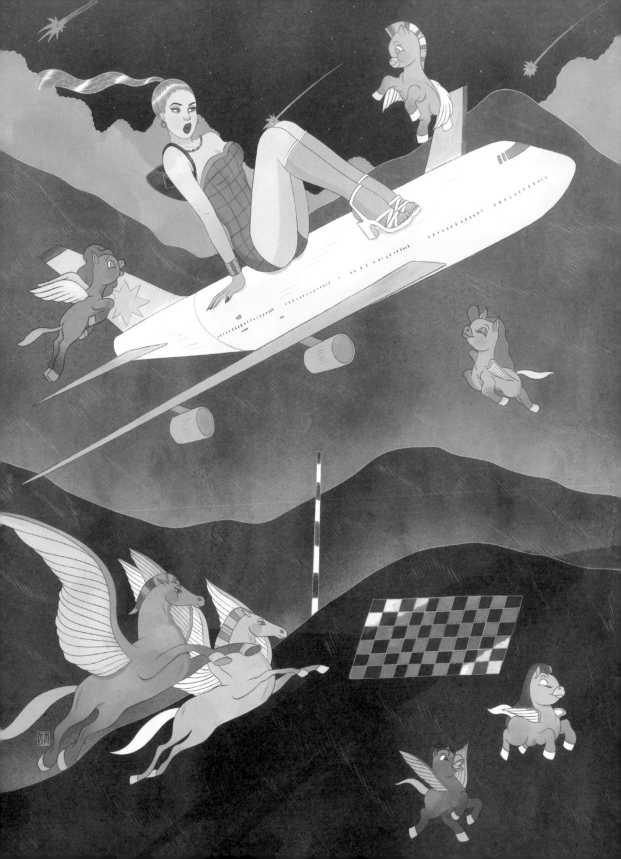

╱飛上月球

我年輕的時候
會在睡夢裡飛越
七大洲與五大洋
樂趣無窮

在那夢中
身旁總坐著我的愛人
只要我開口
他便會帶我飛上月球
深潛海溝

然後你走進我的生命
承諾帶我去米蘭購物
再攀上巴黎鐵塔
在西西里聽風的歌
如今聽來很兒戲
因為無一成真
你早已失去所有熱情
我們曾經享受的熱情
直至我們變回朋友
然後一切幻滅
省掉裝模作樣
倒臥身亡的紫羅蘭

Spirited Away

Spirited Away ain't just a movie,
It has a place in my heart because it moves me.
Sometimes we wander into places that we don't recognize,
And slowly it corrupts us and turns us into swine.
Forgetting our names and purposes,
In this wicked wild world.

We are the captains of our souls,
We are the masters of our fates,
It's up to us to fight our own way out.
Each spirit of us is divine,
Your legacy is yours to define,
Live fast, die young, be wild and have fun.

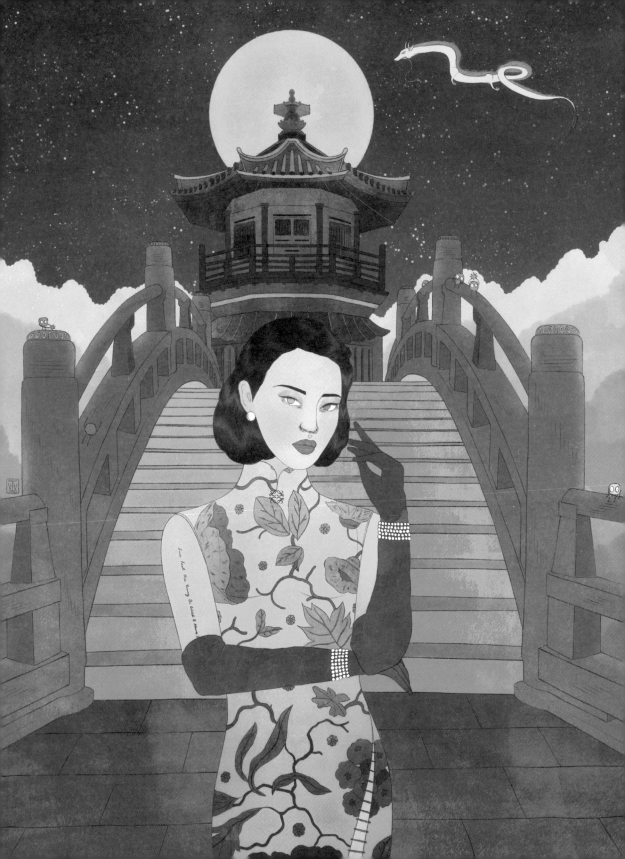

／千與千尋

千與千尋，不止是電影
它打動了我
在我心中有一個獨特位置
有時我們會遊蕩至陌生地
慢慢的，被慾望蠶食為畜生
忘卻名字和目標
就在這狂亂的世界

我們是我們靈魂的主人
我們是我們命運的主宰
只有我們，可為未來奮鬥
所有靈魂都神聖
只有你可成就你
及時行樂要緊記
誓要狂歡至死

Buy Me a Drink

Hello there,

The one who gives me a hella stare,

I thought you two were a pair,

Like why would I care?

Walking in front of me you asked "Can I buy you a drink?"

I said why not? You look cute and hot.

We dance and hug but then someone else came in,

Someone cuter and hotter,

Skin to skin, lip to lip,

How can you randomly kiss someone that fast?

Like our relationship just last for three seconds,

Blackened face, smile erased,

Please just stop,

Don't do this in front of me,

All that pressure makes me wanna leave,

My heart splits, It does not feel good I'll admit,

I'll rather walk alone in the streets.

Will I ever be completed?

Love is a complete mess.

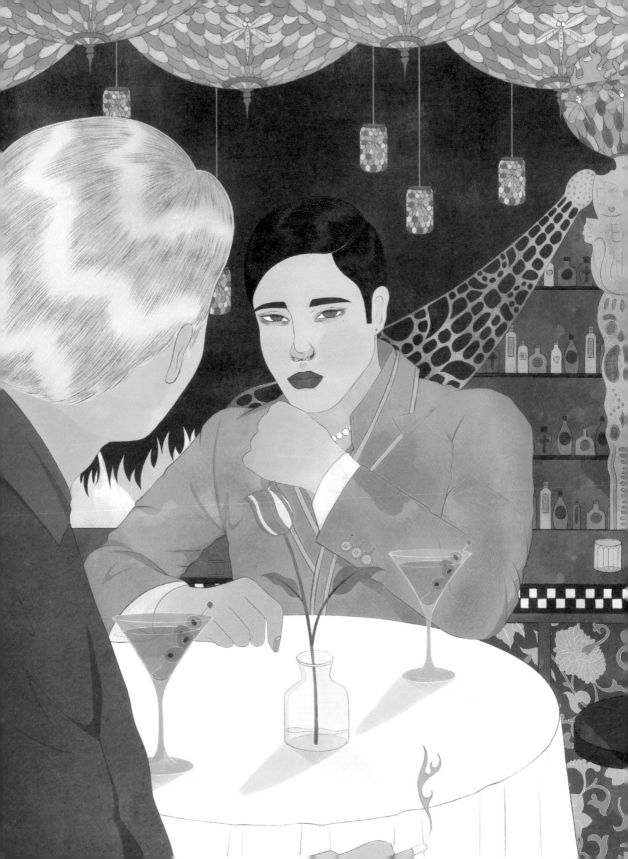

／請我飲杯酒

你好
不斷注視我的人
我以為你倆是一對
別誤會，我從不在意
你走近問我：
「可唔可以請你飲杯酒？」
「點解唔可以？」你帥氣又可愛
我們擁抱共舞，直至另一人走進來
一個更可愛更帥的人
身貼身，唇貼唇
你怎可瞬間擁吻另一人？
只維持三秒的戀情
眉頭緊皺，笑容消逝
請你停止
遠離我視線
重壓之下我渴望逃離
內心撕裂，無盡鬱結
情願一人躲進大街，不說道別
我何時可不再破裂？

愛情是一齣徹底鬧劇

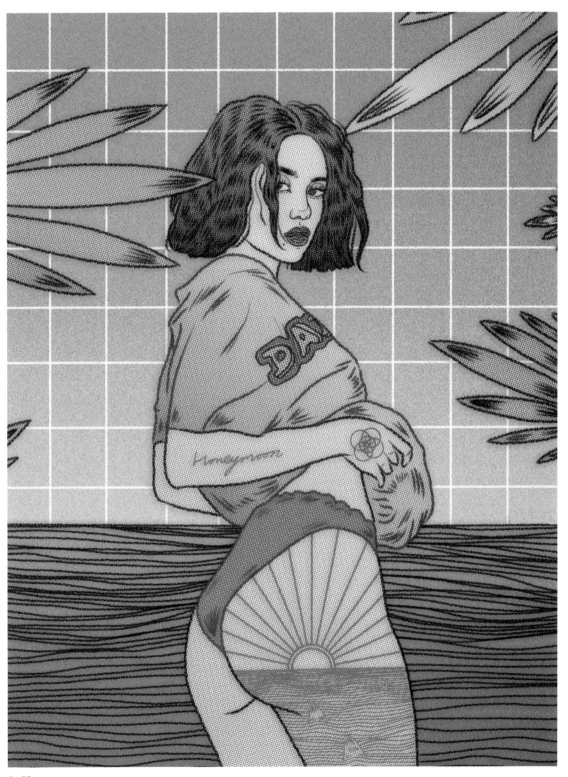

1. Honeymoon

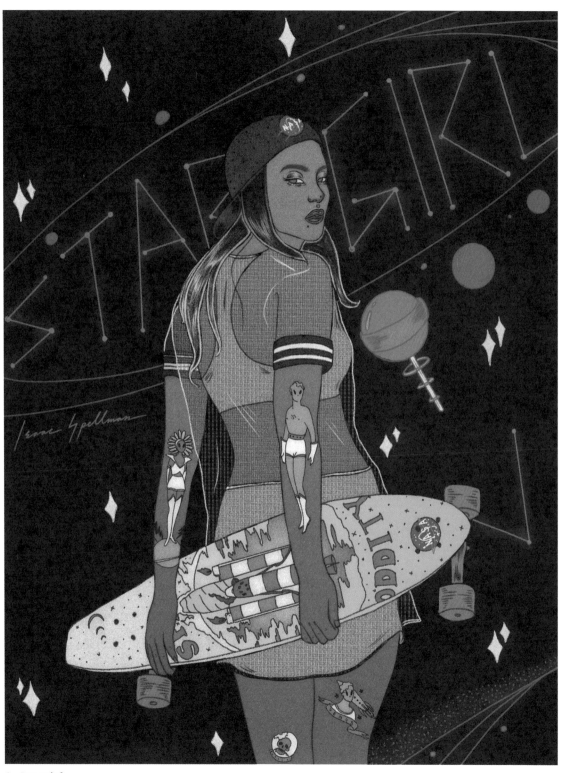

2. Stargirl

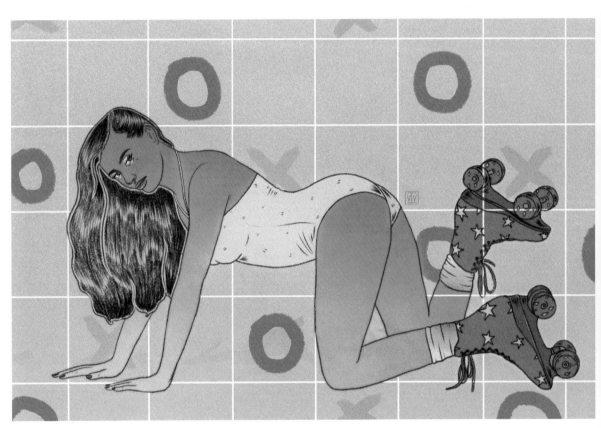

3. XO

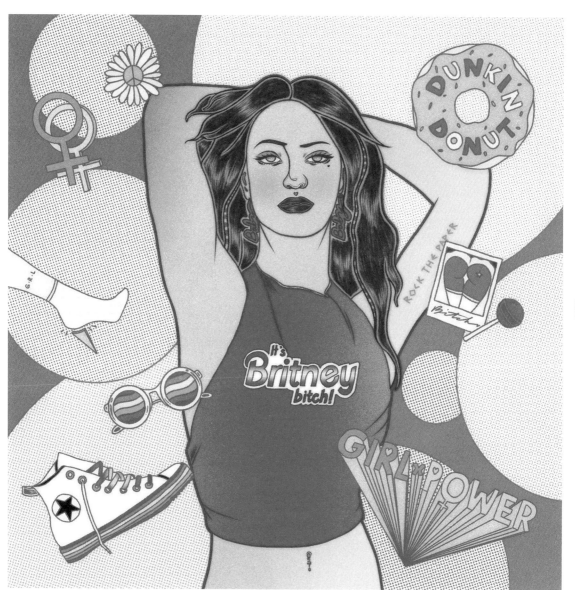

4. It's Britney Bitch

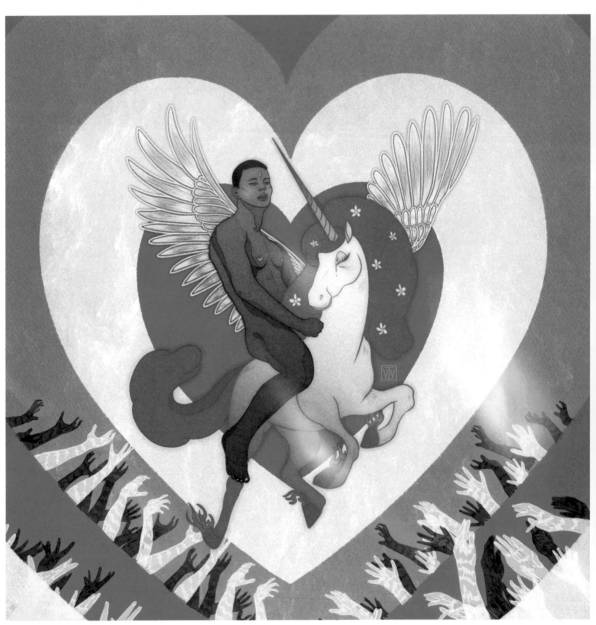

5. Prince Charming

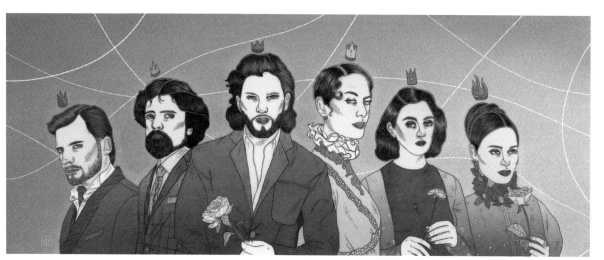

6. Game Of Thrones

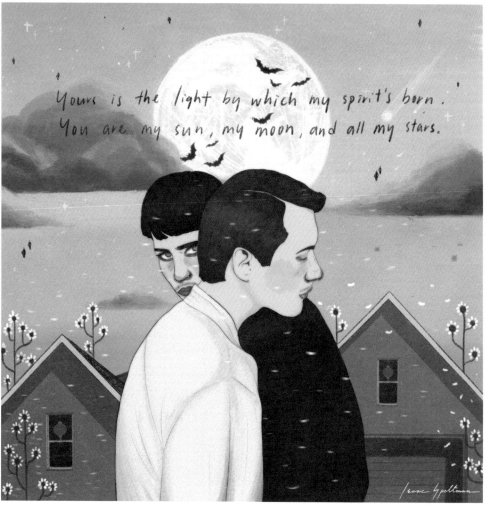

7. Moon Lover

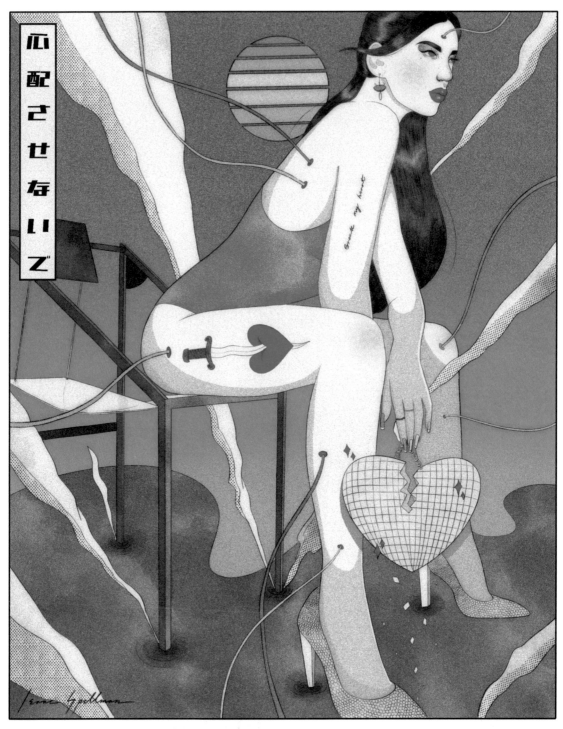

8. Break My Heart (Published on Vogue Russia)

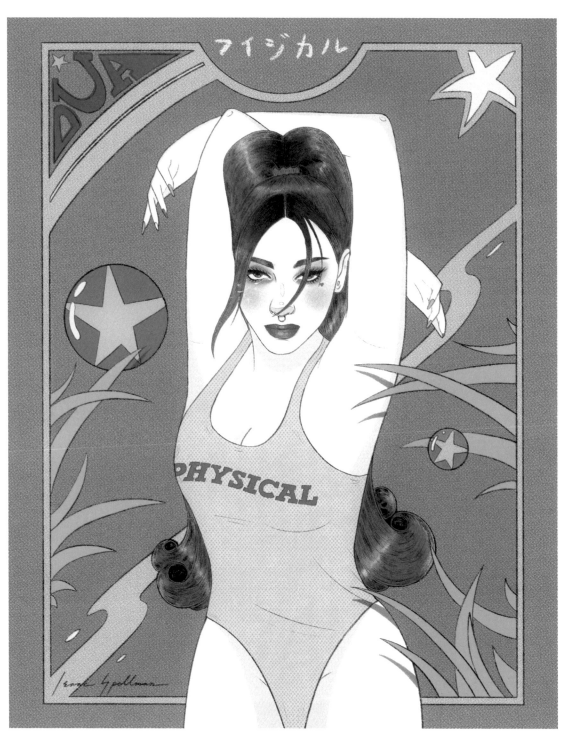

9. PHYSICAL! (Published on Vogue Russia)

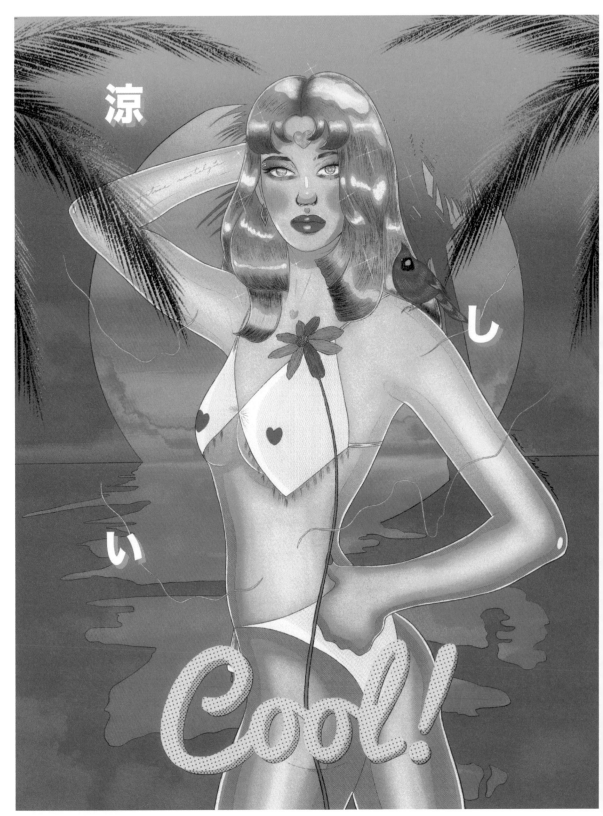

10. Cool!

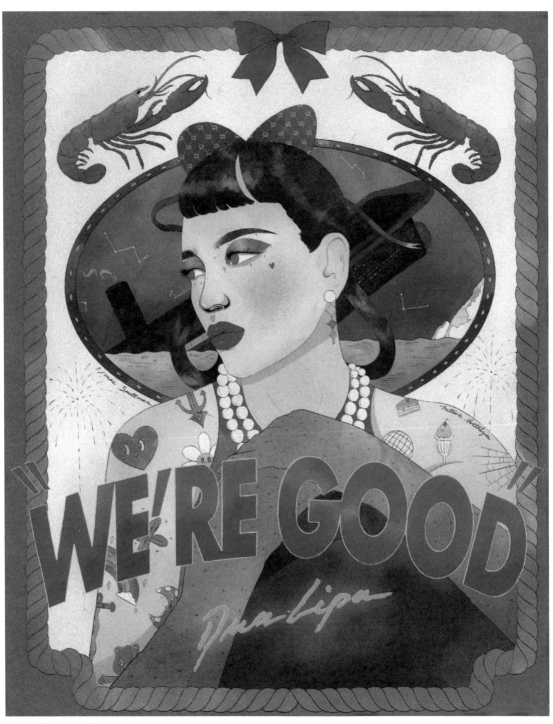

11. We're Good

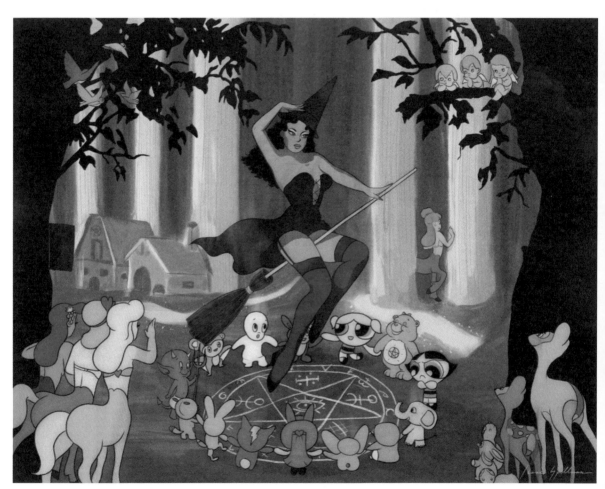

12. Enchanted Forest

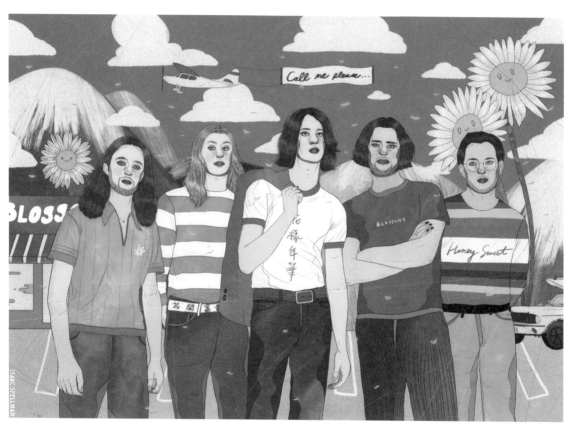

13. Blossoms

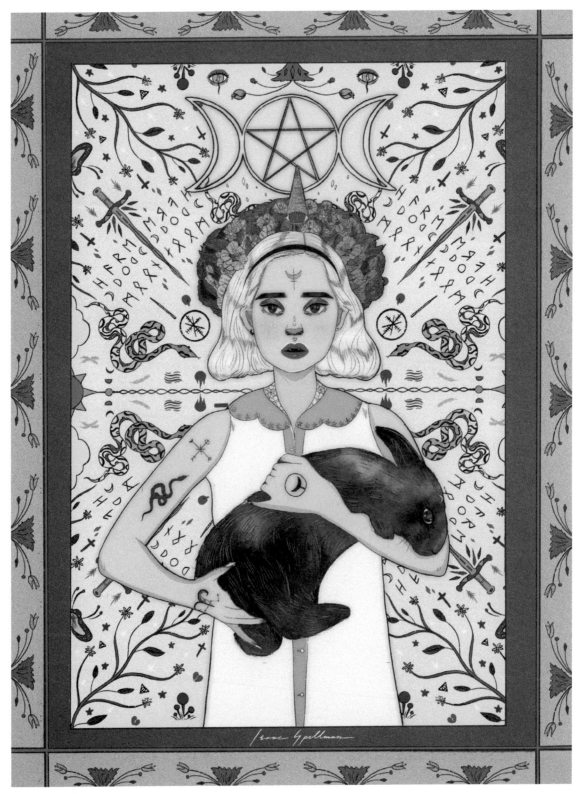

14. Hare Moon

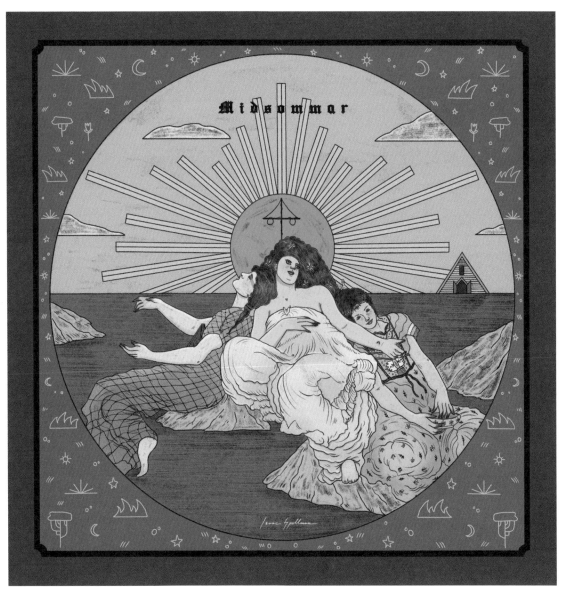

15. Midsommar

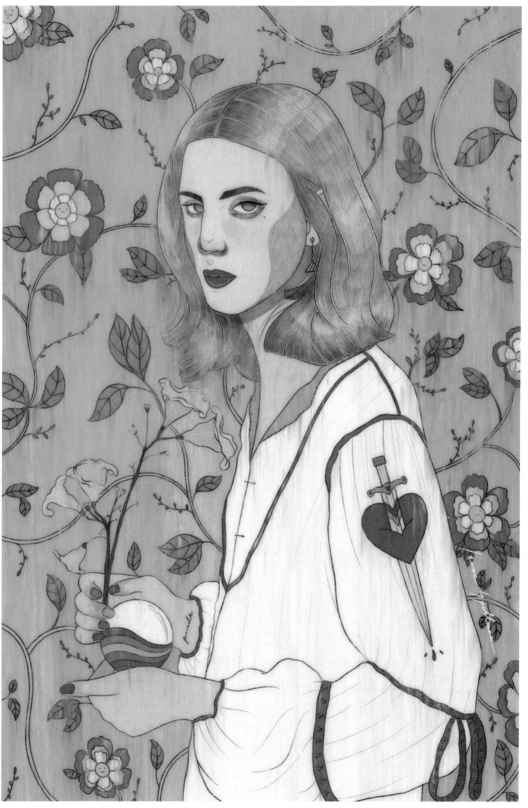

16. PRIDE

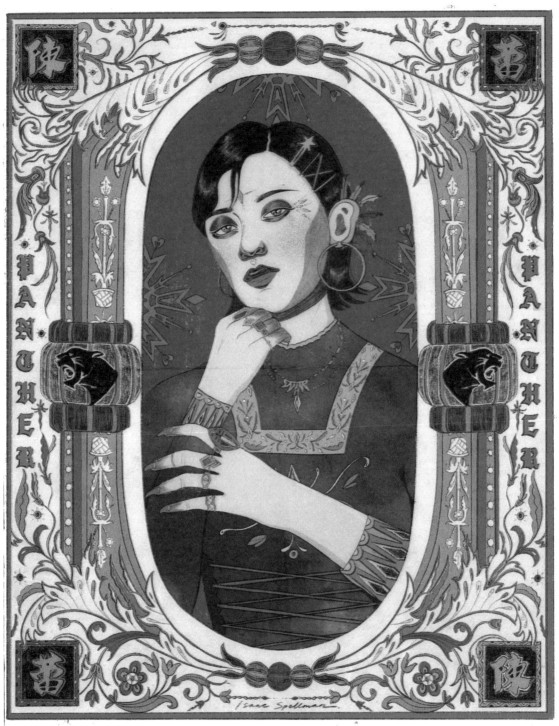

173

17. PANTHER (Commissioned by Ztoryteller)

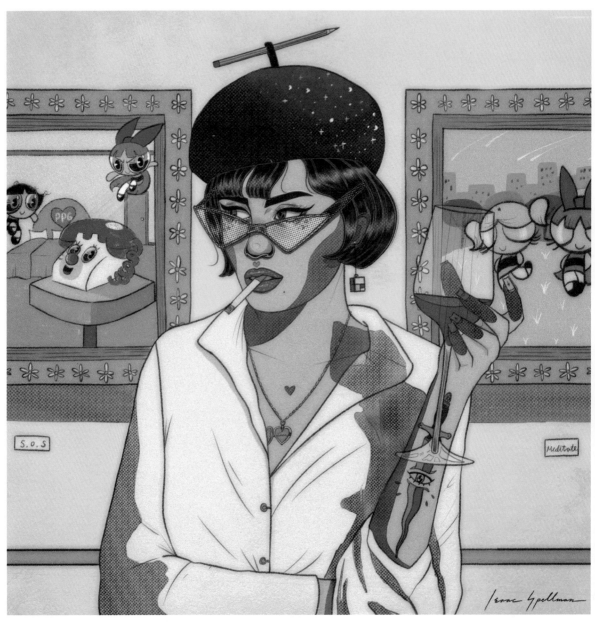

18. Sugar, Spice & Everything Nice

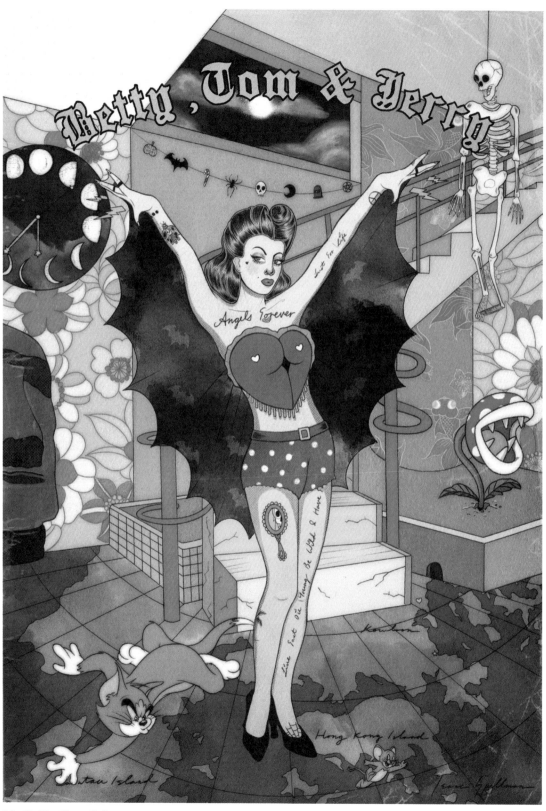

19. Betty, Tom & Jerry

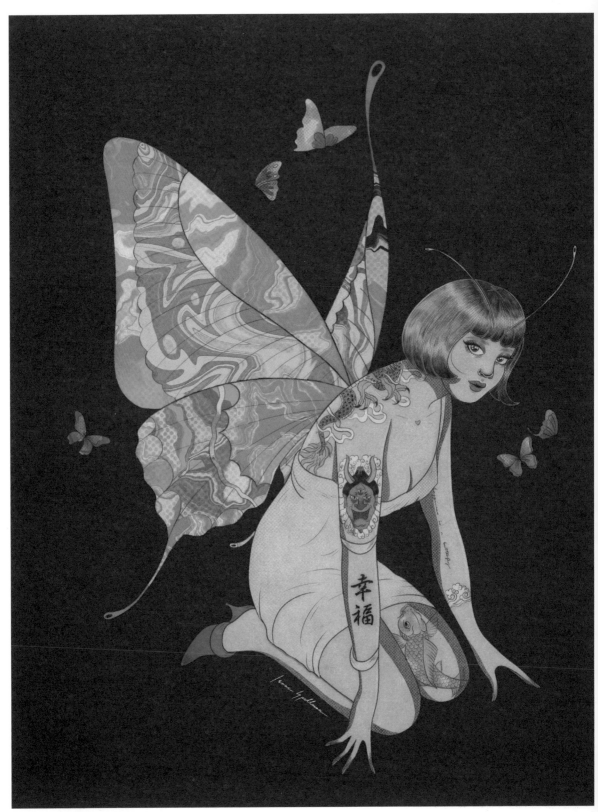

20.Happiness Is A Butterfly

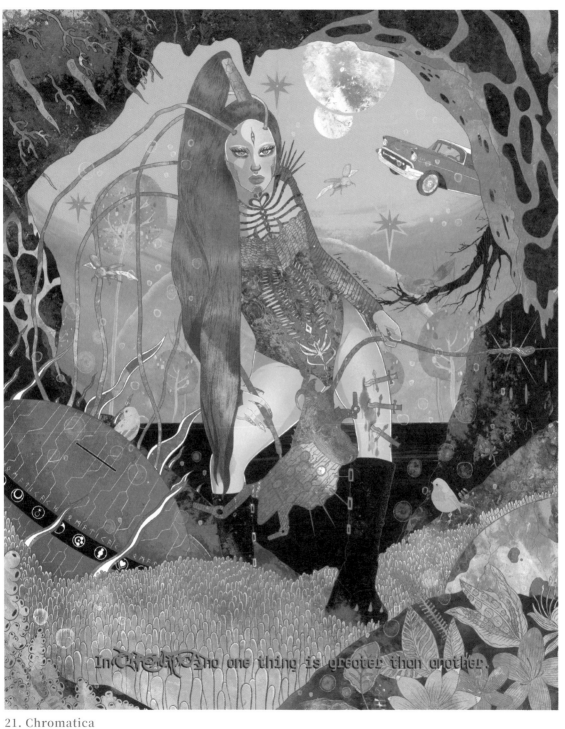

In The Gap no one thing is greater than another.

21. Chromatica

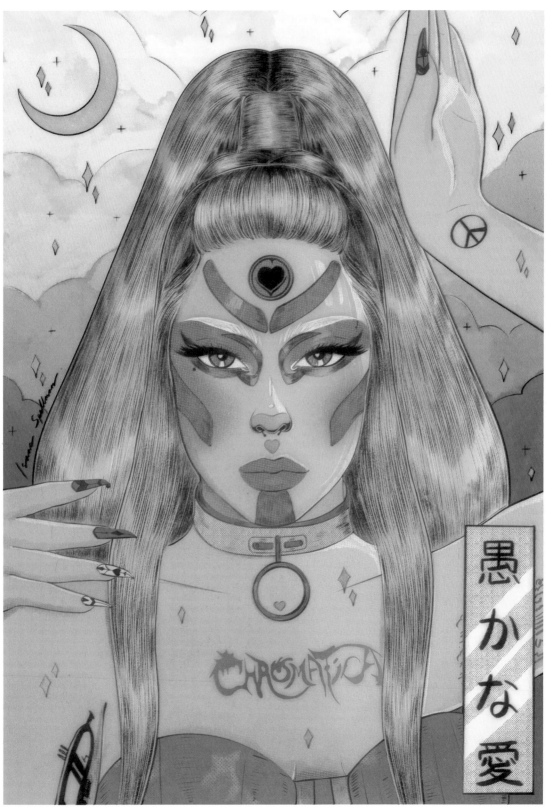

22. Stupid Love

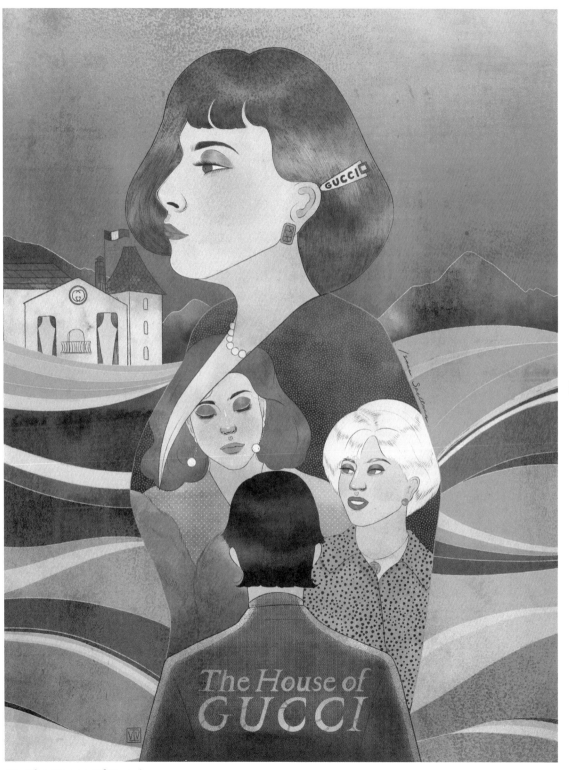

23. The House Of Gucci

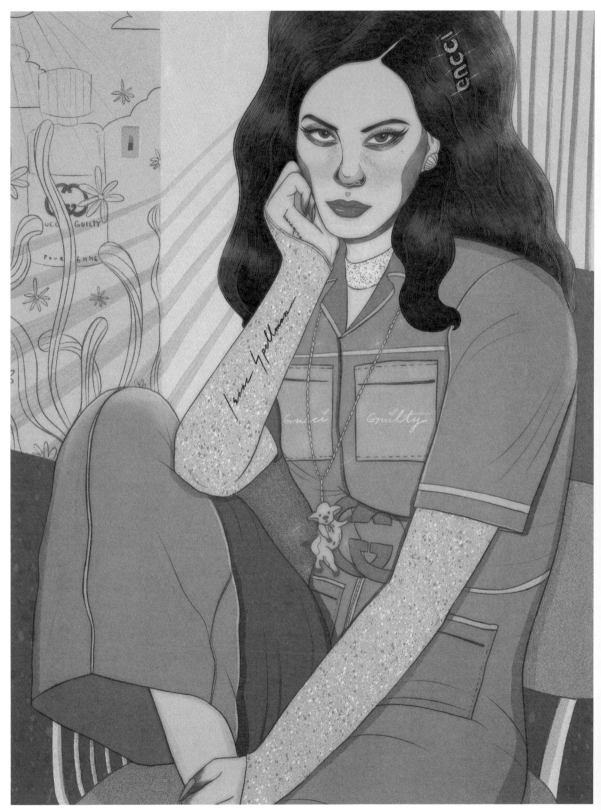

24. Gucci Guilty

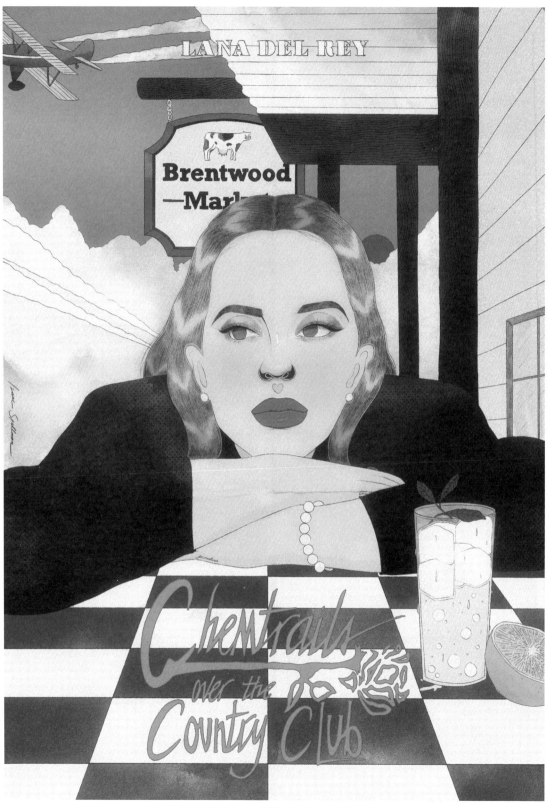

25. Chemtrails (Commissioned by Universal Music Hong Kong)

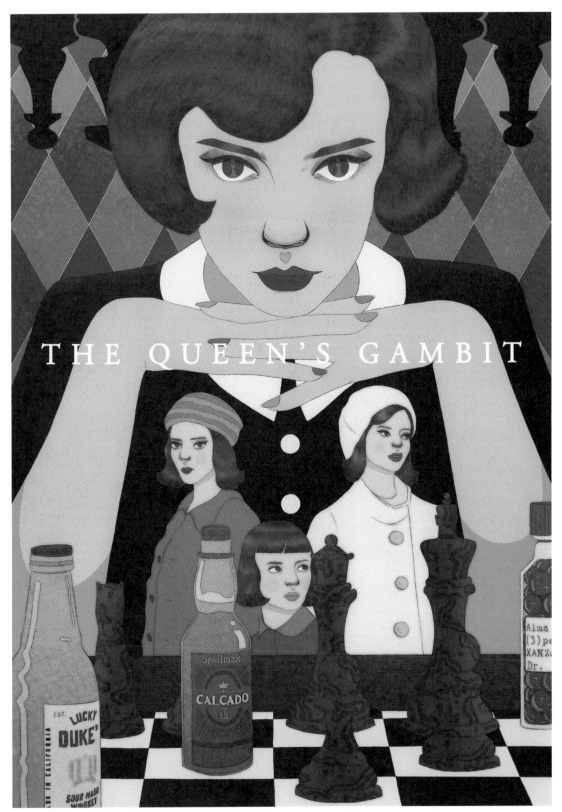

THE QUEEN'S GAMBIT

26. The Queen's Gambit

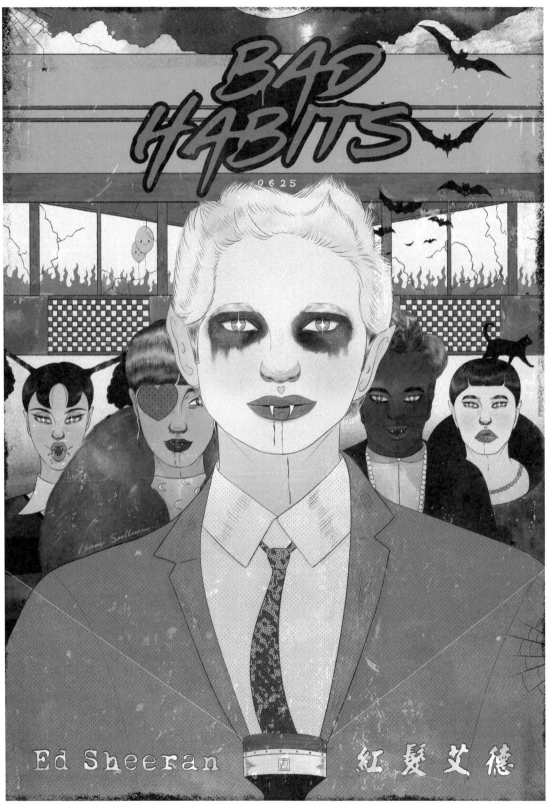

27. Bad Habits (Commissioned by Warner Music Hong Kong)

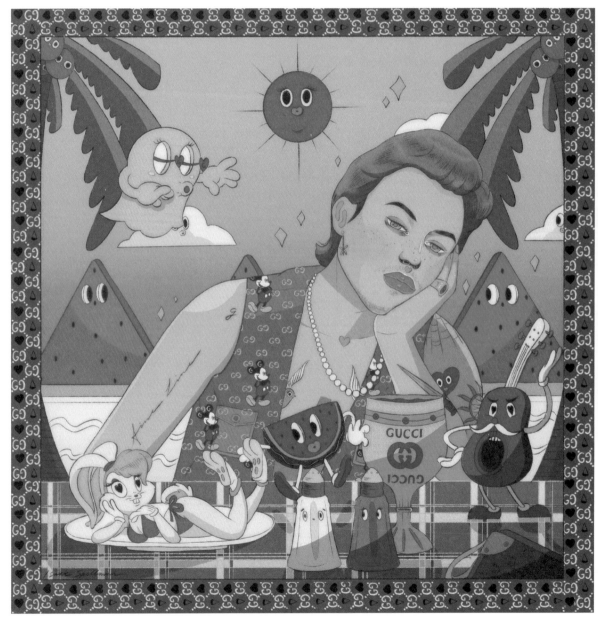

28. Watermelon Sugar

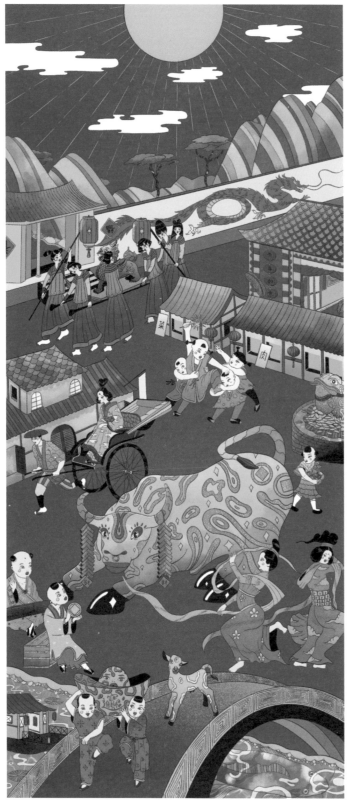

185

29. Year Of Ox 2021 (Commissioned by Deutsche Bank)

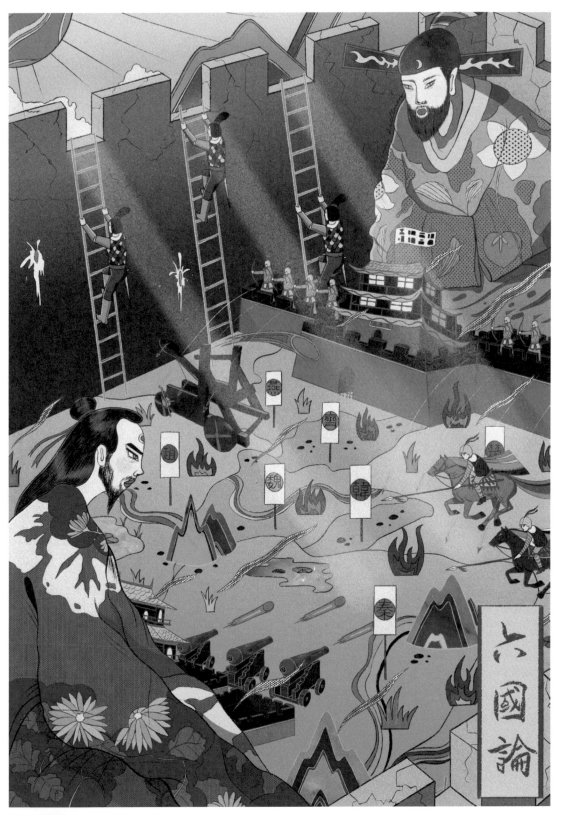

30. 六國論

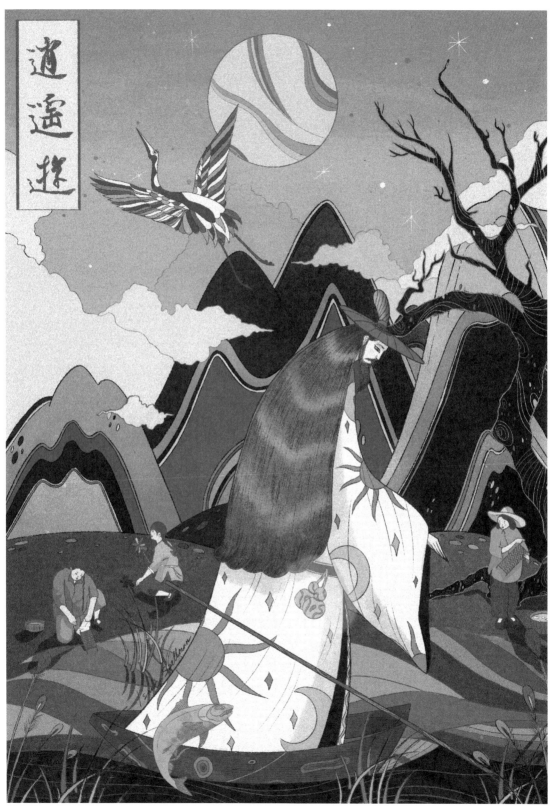

逍遙遊

187

31. 逍遙遊

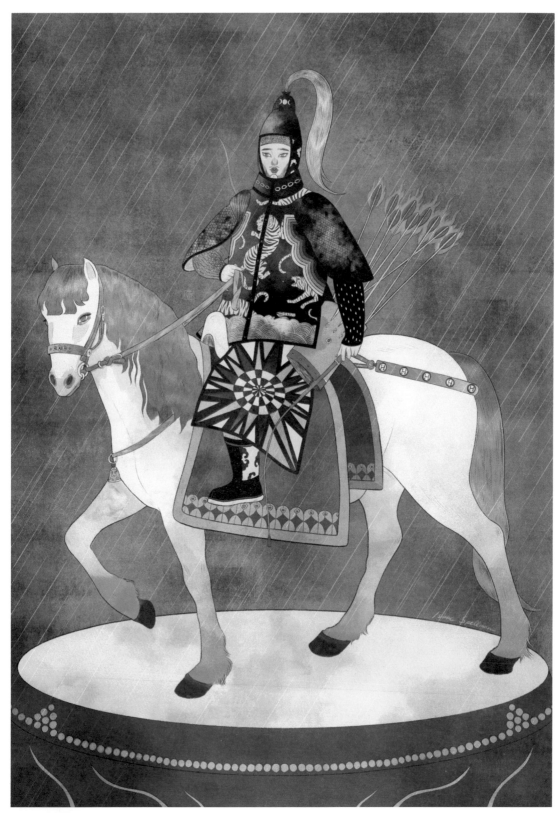

32. 曹劌論戰

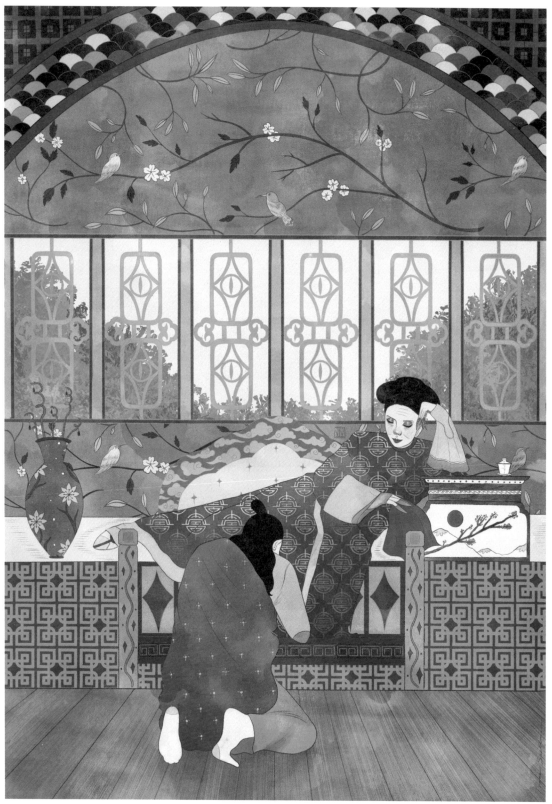

33. 陳情表

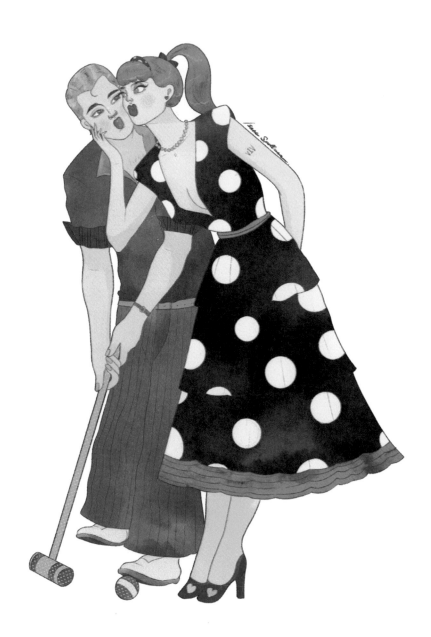

34. Vogue: Kissing (For Vogue Hong Kong)

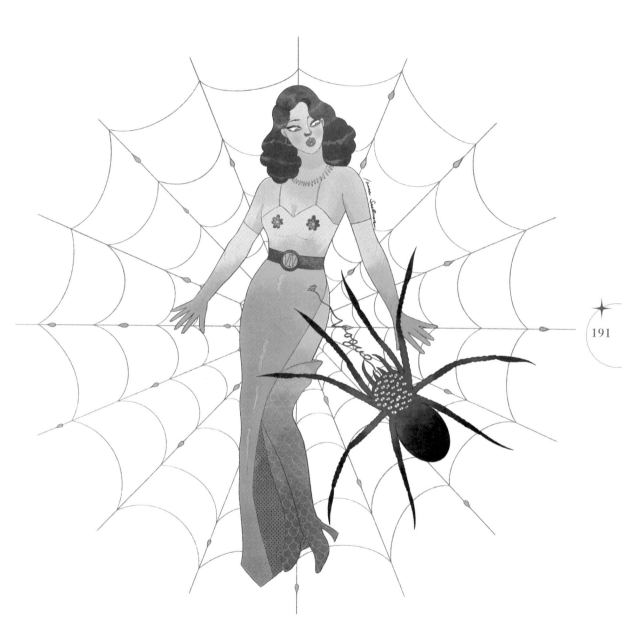

35. Vogue: Monster (For Vogue Hong Kong)

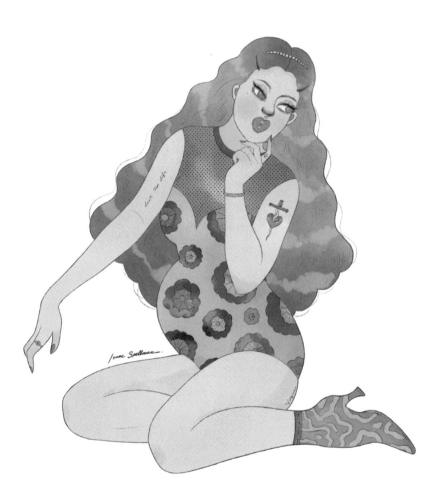

36. Vogue: Pregnant (For Vogue Hong Kong)

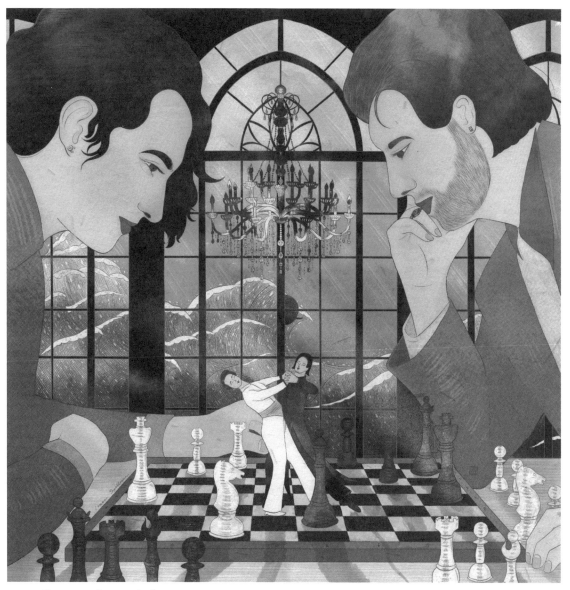

37. Ballroom Of My Mind

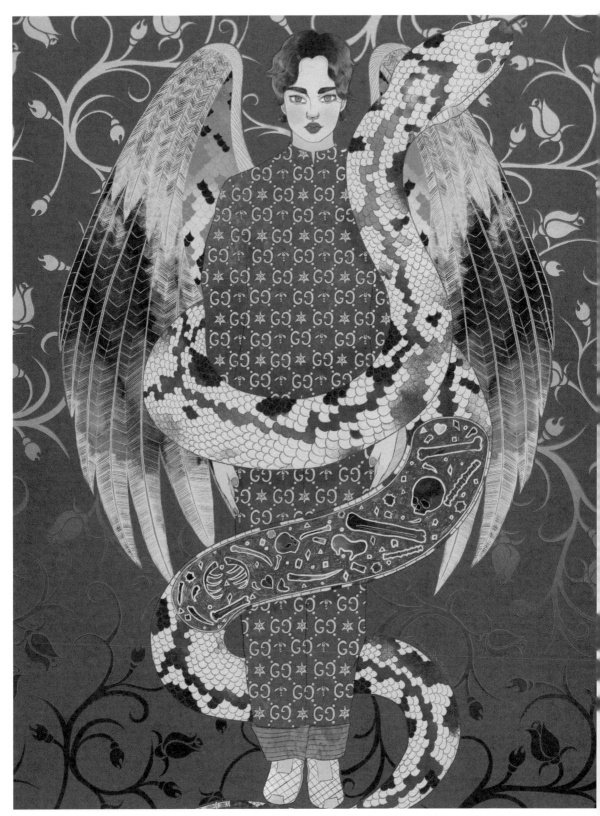

38. Salem Attack

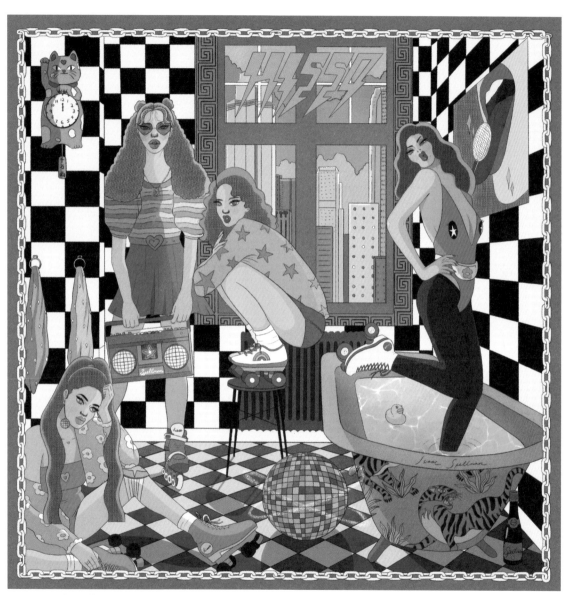

39. Heartbreak Hotel (Commissioned by Hisso)

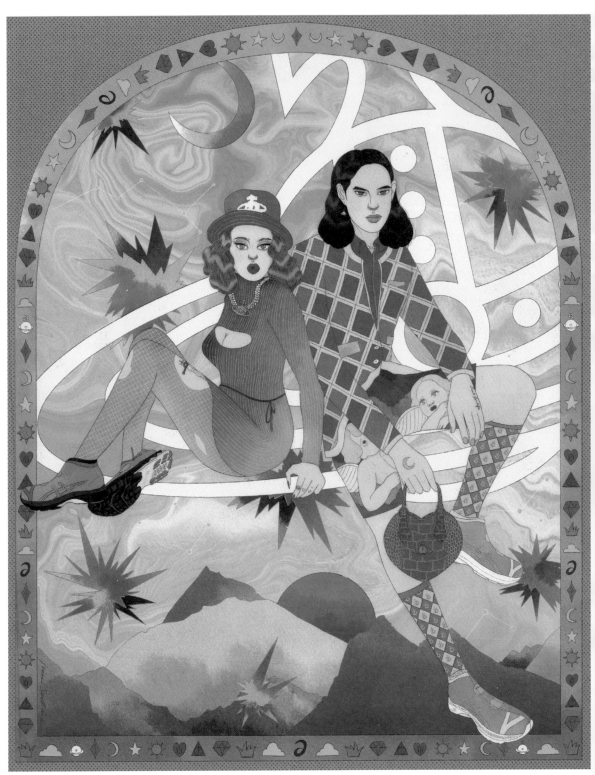

40. Vivienne Westwood (For Vivienne Westwood Hong Kong)

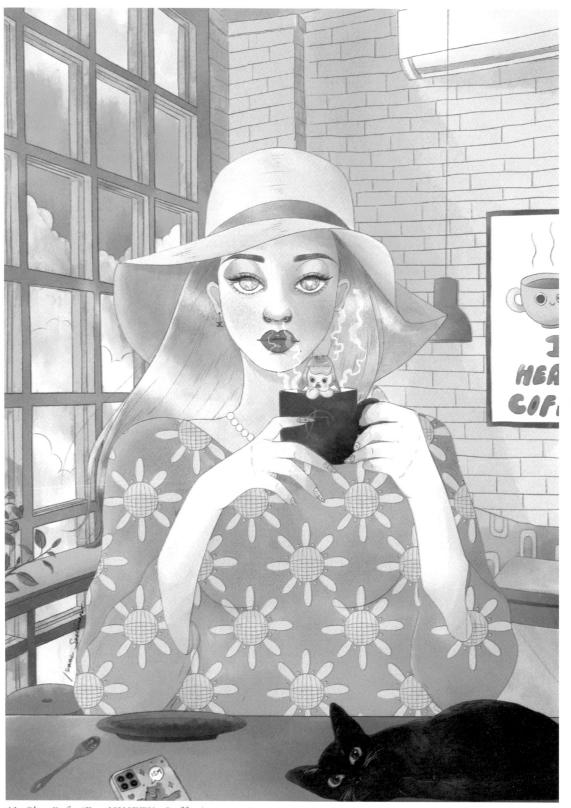

41. Sky Cafe (For NINETYs Coffee)

42. Last Christmas

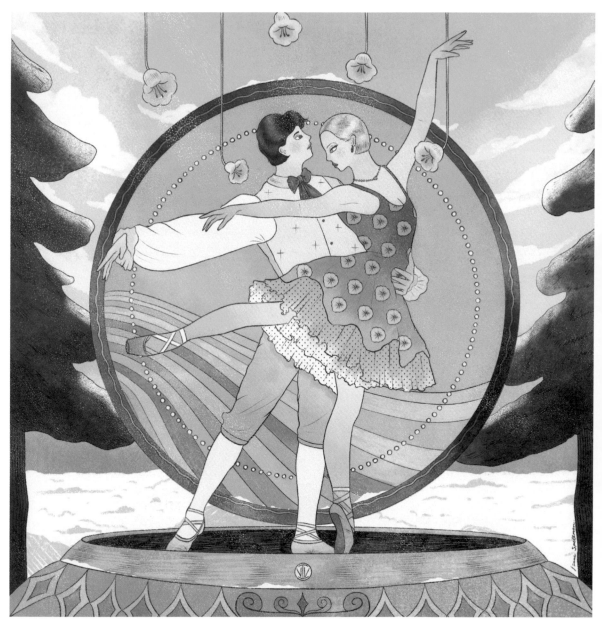

43. Winter's Dance

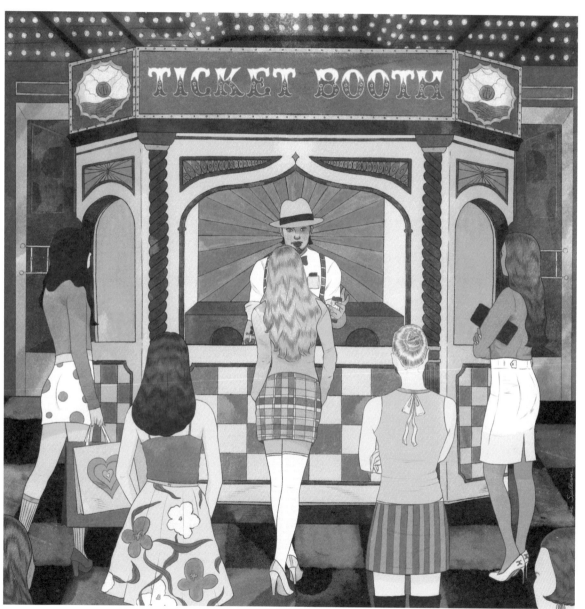

44. Ticket Booth

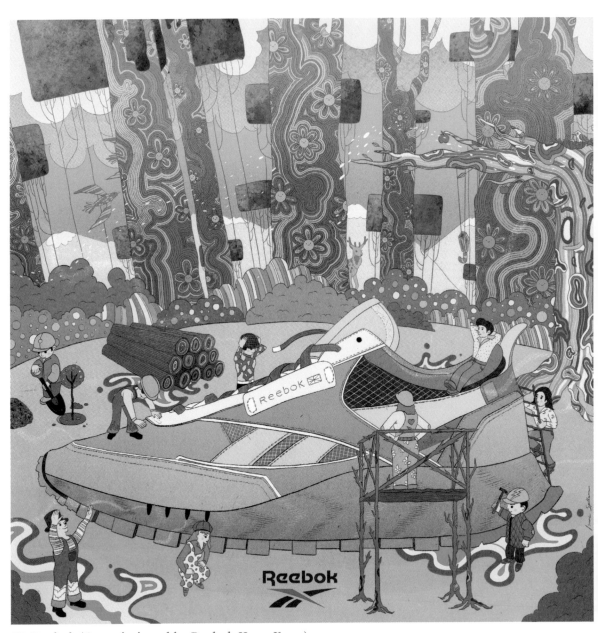

45. Reebok (Commissioned by Reebok Hong Kong)

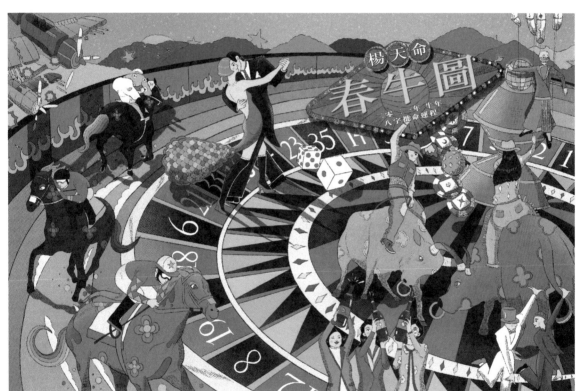

46. 春牛圖 (Commissioned by 楊天命 Alion Yeo)

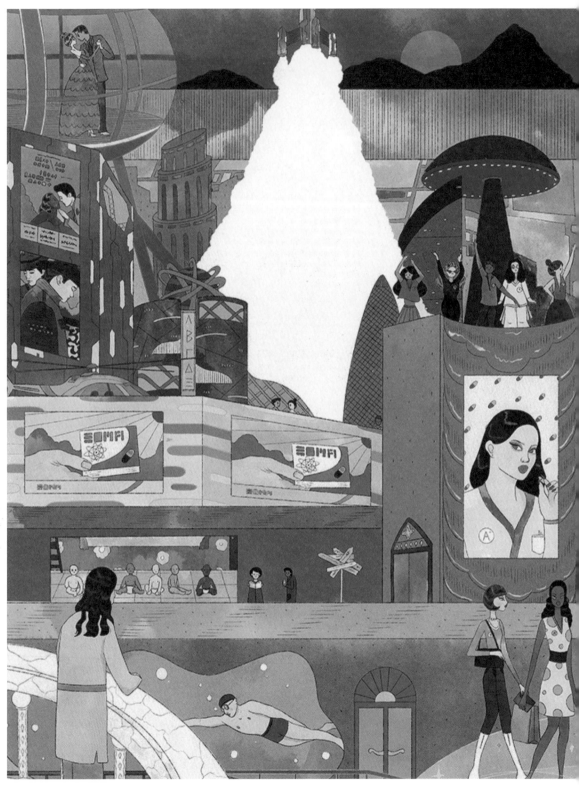

47. Brave New World (Commissioned by Cup Publishing)

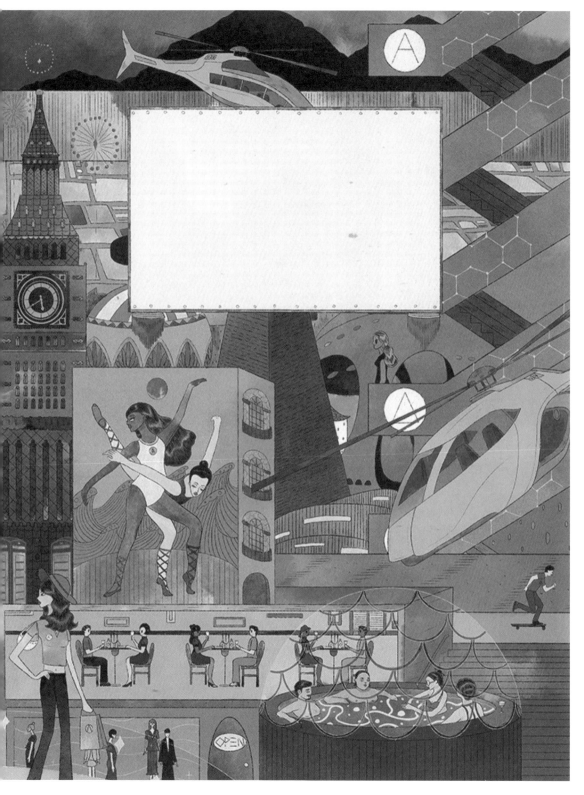

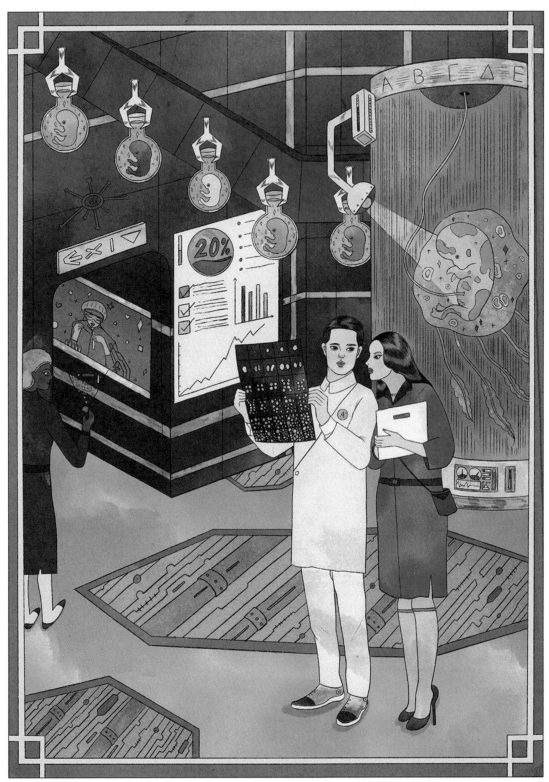

48. The Lab (Commissioned by Cup Publishing)

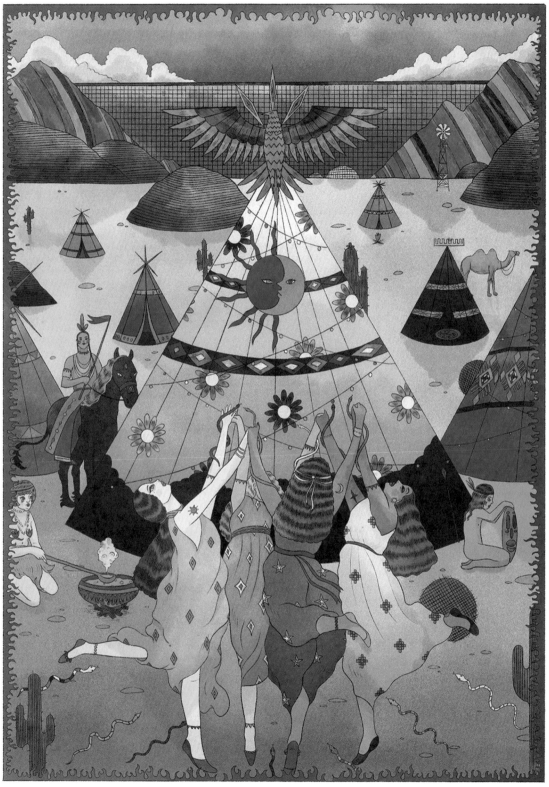

49. Summer Festival (Commissioned by Cup Publishing)

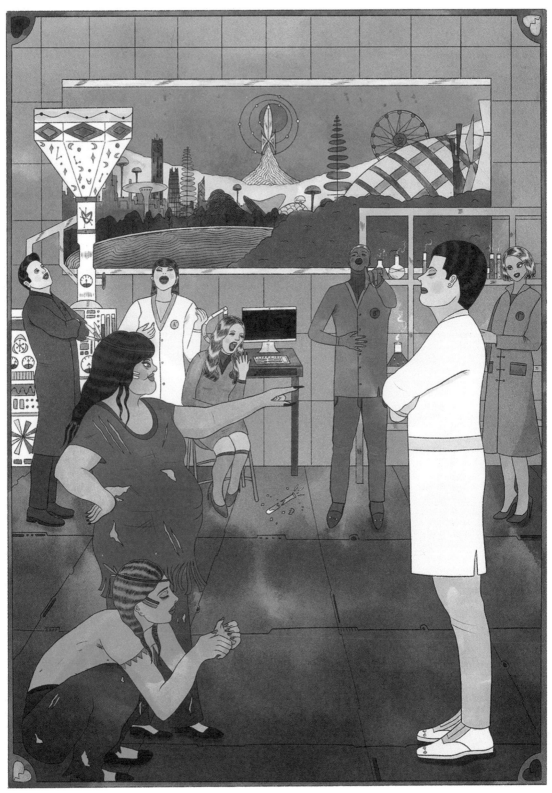

50. Father! (Commissioned by Cup Publishing)

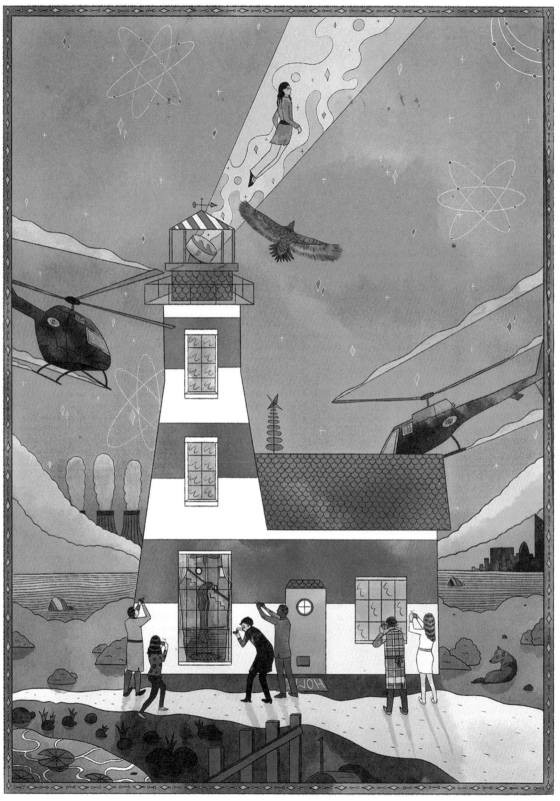

51. Lighthouse (Commissioned by Cup Publishing)

52. **Brave New World Tapestry (Commissioned by Cup Publishing)**

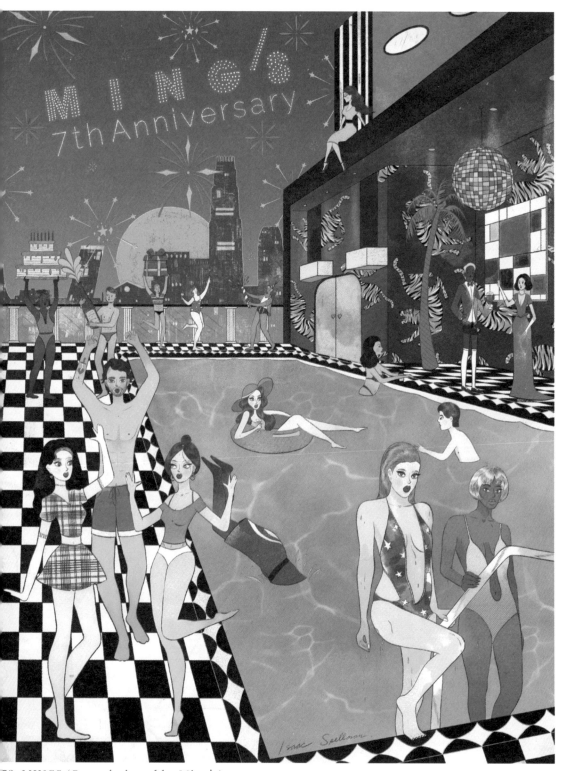

53. MINGS (Commissioned by Ming's)

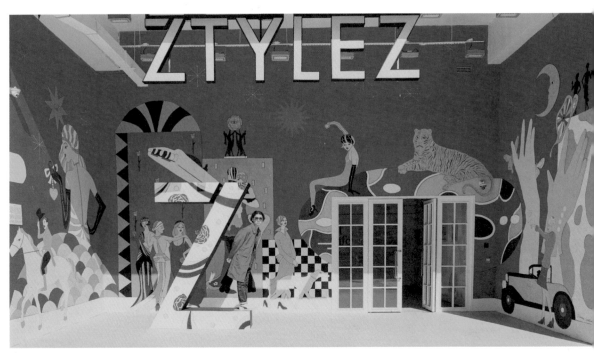

54. Lust For Life Mural (Commissioned by ZTYLEZ)

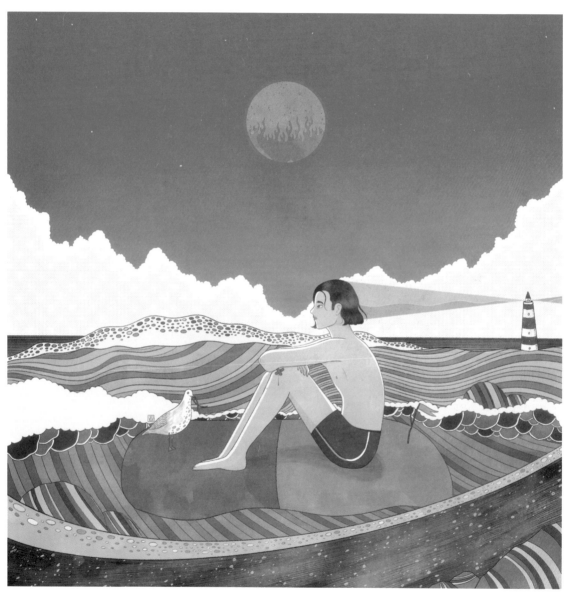

55. Sad Little Pill (Commissioned by Red Ribbon Centre)

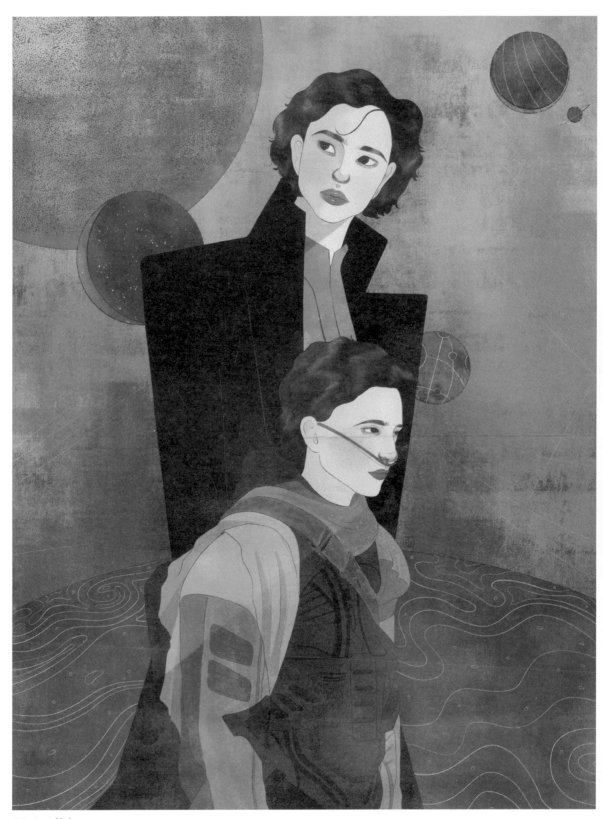

56. Realities

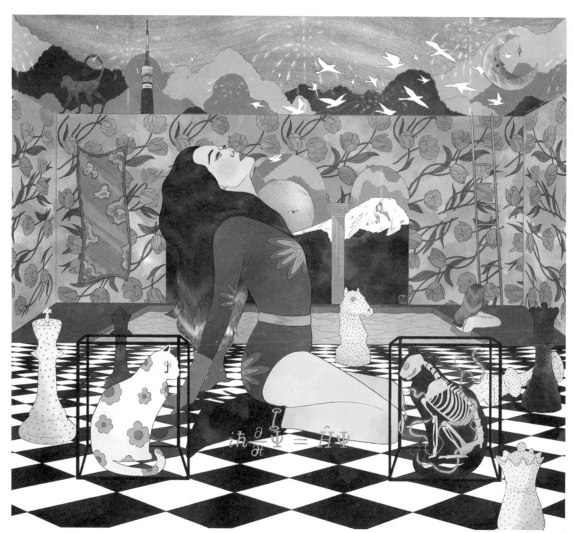

57. Schrodinger's Cat (Commissioned by 容祖兒 Joey Yung)

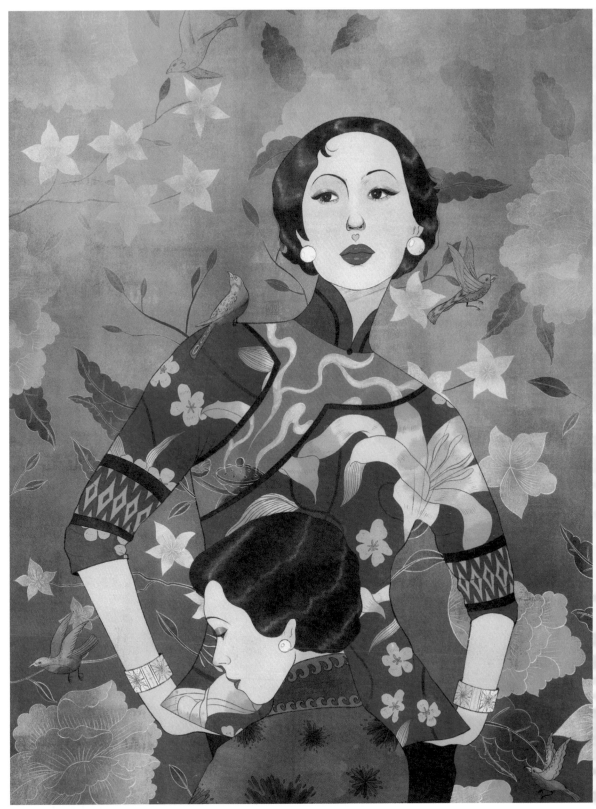

58. Love After Love (Commissioned by Art & Piece)

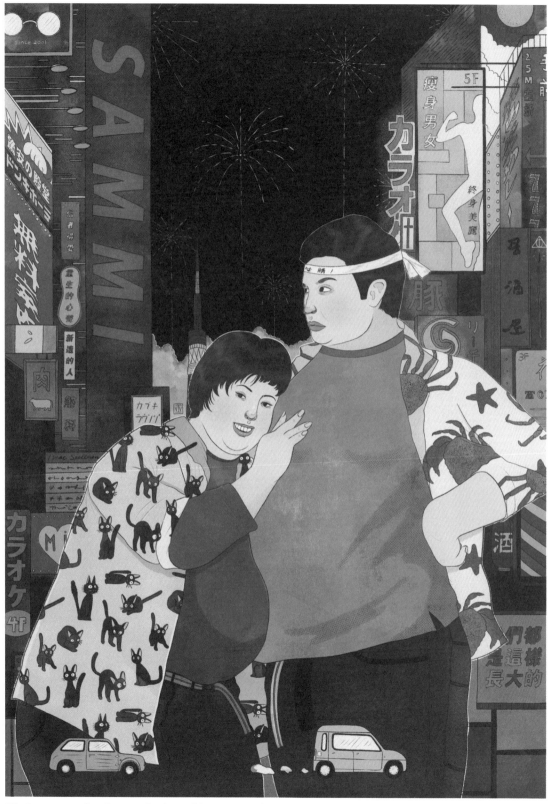

59. Love on Diet (Commissioned by Art & Piece)

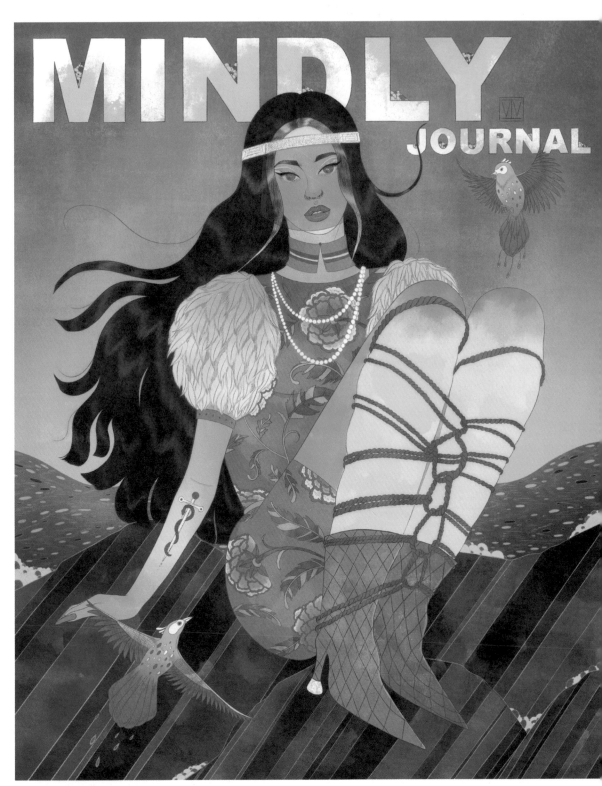

60. Mindly Journal (For Mindly Journal)

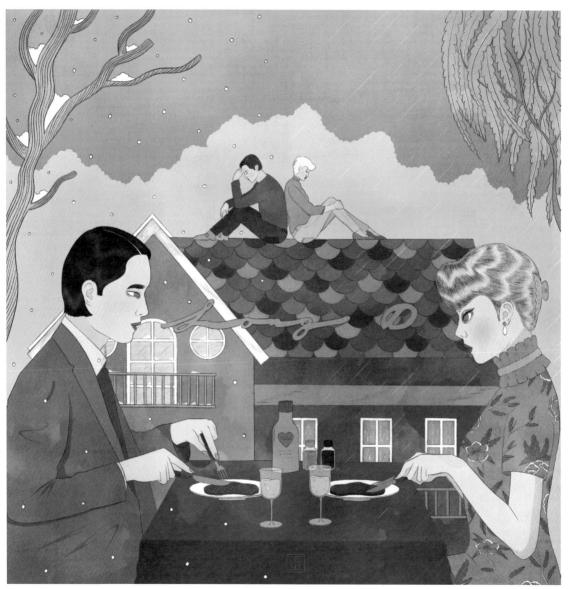

219

61. Long D (Commissioned by Universal Music Hong Kong)

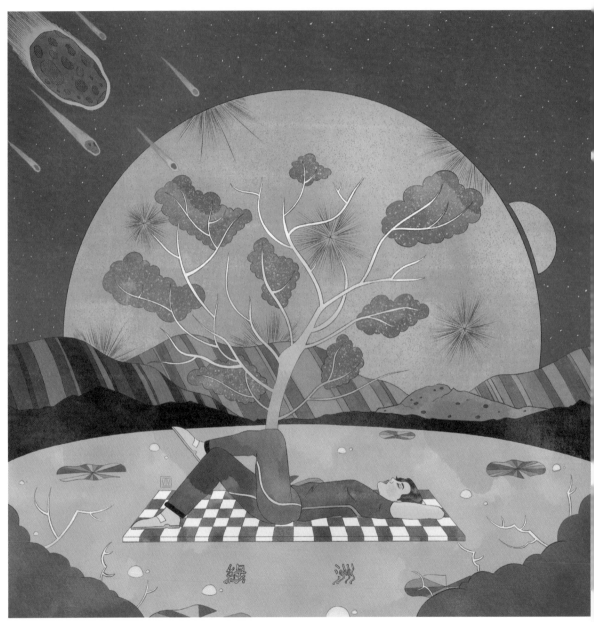

62. Oasis (Commissioned by Universal Music Hong Kong)

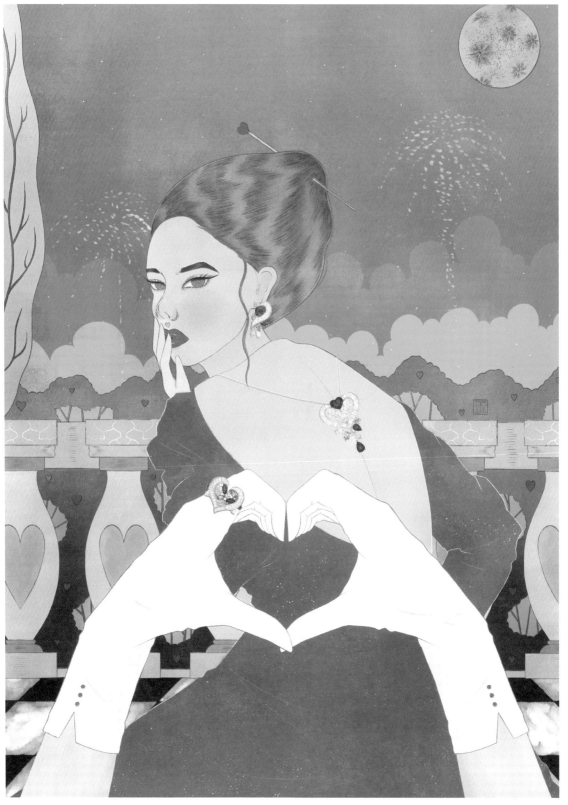

63. Harry Winston (Commissioned by Harry Winston)

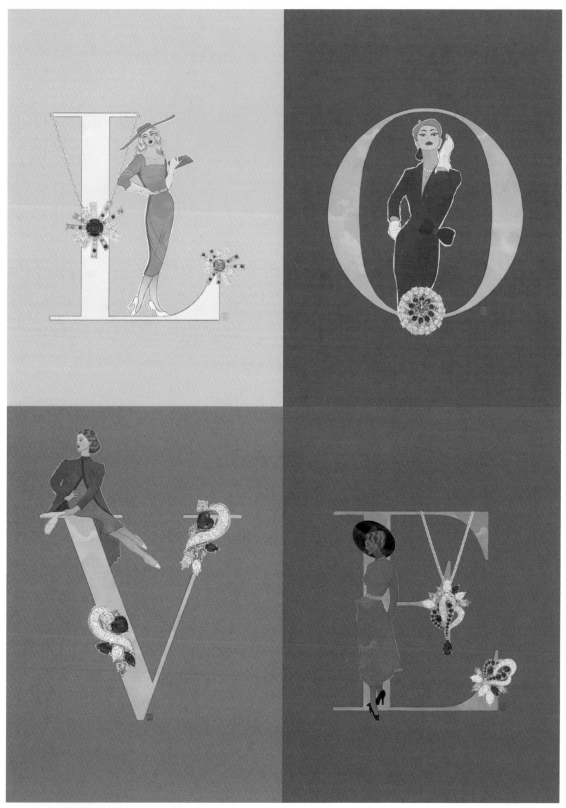

64. L.O.V.E Collection (Commissioned by Harry Winston)

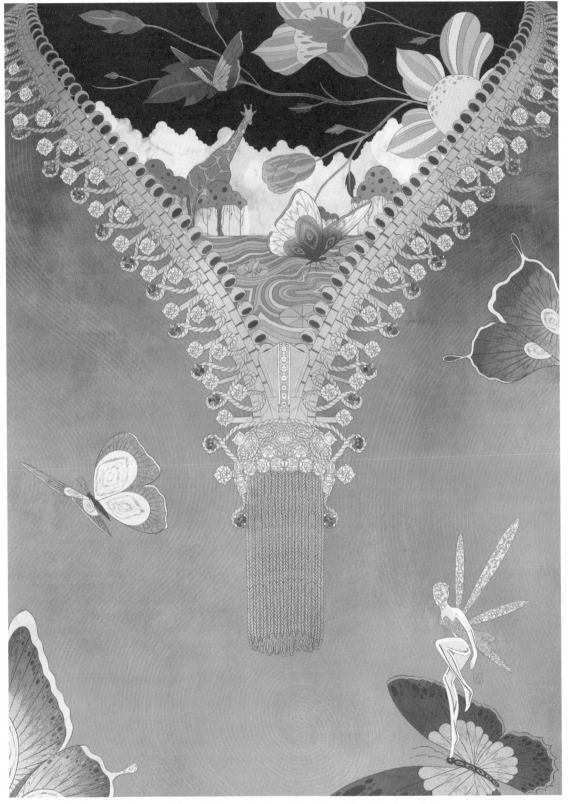

65. Van Cleef & Arpels: Necklace (Commissioned by Van Cleef & Arpels)

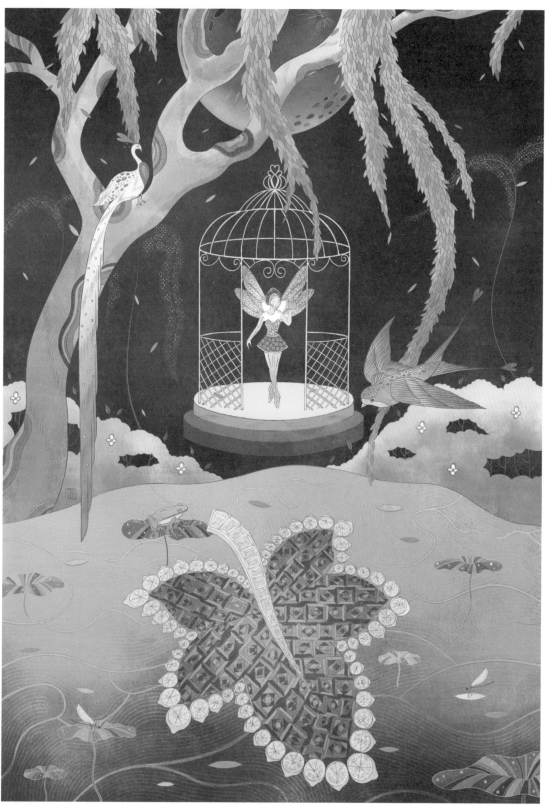

66. Van Cleef & Arpels: Leaf (Commissioned by Van Cleef & Arpels)

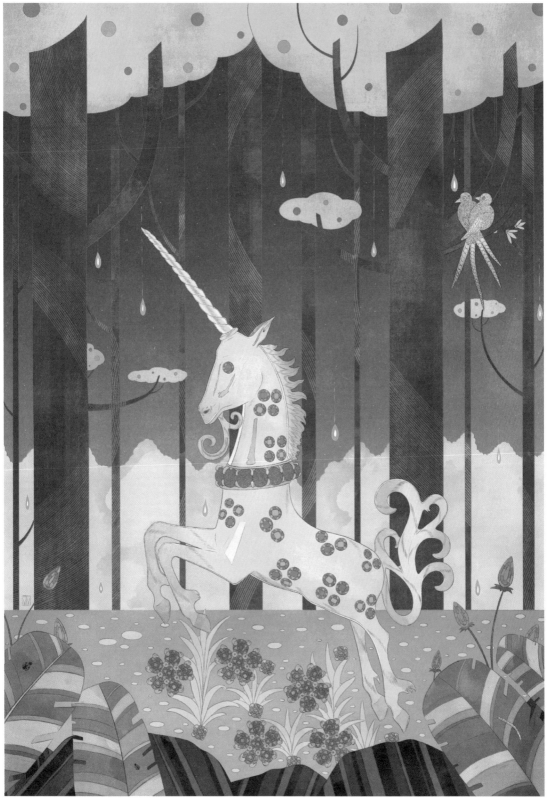

67. Van Cleef & Arpels: Unicorn (Commissioned by Van Cleef & Arpels)

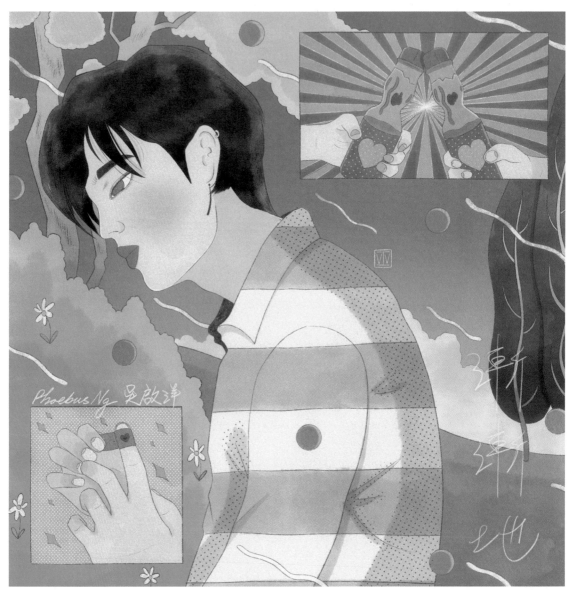

68. Phoebus Ng 漸漸地 (Commissioned by Universal Music Hong Kong)

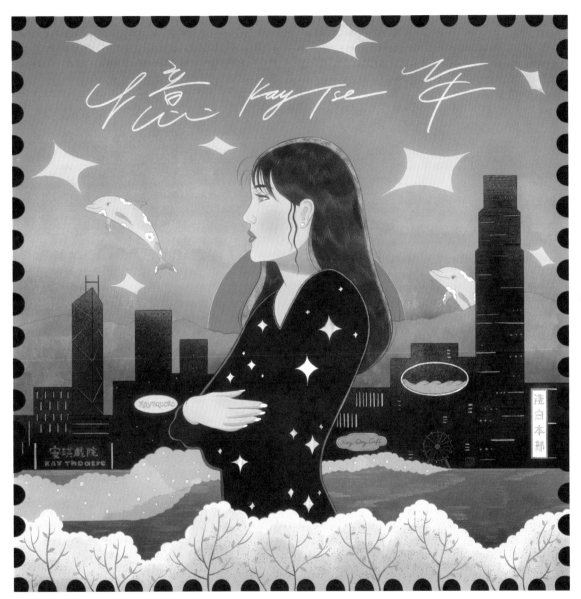

69. 憶年 (Commissioned by 謝安琪 Kay Tse)

作者：Isaac Spellman 巫男

助手：Mo Yim

翻譯（中文文稿）：Ken Wong

編輯：Annie Wong、Sonia Leung、Tanlui

實習編輯：Iris Li

校對：馬柔

美術總監：Billy Chan

書籍設計：方包

出版：白卷出版有限公司

新界葵涌大圓街 11-13 號同珍工業大廈 B 座 16 樓 8 室

網址：www.whitepaper.com.hk

電郵：email@whitepaper.com.hk

發行：泛華發行代理有限公司

電郵：gccd@singtaonewscorp.com

承印：Ideastore(HK) Limited

版次：2022 年 6 月 初版

ISBN：978-988-74870-9-8

Author: Isaac Spellman
Assistant: Mo Yim
Translator (Chin. text): Ken Wong
Editor: Annie Wong、Sonia Leung、Tanlui
Editorial intern: Iris Li
Proofreader: Mayau
Art Director: Billy Chan
Book Design: Fong Bao

Publisher: Whitepaper Publishing Limited
Unit 8, 16/F, Block B, Tung Chun Industrial Building,
11-13 Tai Yuen Street, Kwai Chung, NT
Website: www.whitepaper.com.hk
Email: email@whitepaper.com.hk
Circulated by Global China Circulation & Distributor Ltd.
Email: gccd@singtaonewscorp.com
Printed by Ideastore(HK) Limited

First published in June 2022
ISBN：978-988-74870-9-8